Tempo

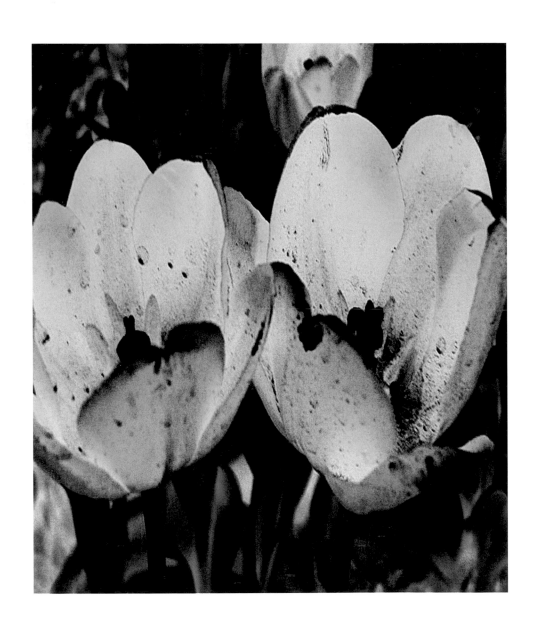

Tempo

Paulo Herkenhoff

Roxana Marcoci

Miriam Basilio

The Museum of Modern Art, New York
Distributed by D.A.P./Distributed Art Publishers, Inc., New York

Published on the occasion of the exhibition, *Tempo,* organized by Paulo Herkenhoff, Adjunct Curator, with the assistance of Roxana Marcoci and Miriam Basilio, Department of Painting and Sculpture, The Museum of Modern Art, New York, June 29–September 9, 2002.

This exhibition is supported by Philip Morris Companies Inc.
Additional support is provided Agnes Gund and Daniel Shapiro and by The Contemporary Arts Council of The Museum of Modern Art.
The accompanying educational programs are made possible by BNP Paribas.
LCD monitor, plasma displays, and DVD players courtesy of Hitachi America, Ltd.
Travel support provided by Goethe-Institut Inter Nationes, New York.

Produced by the Department of Publications
The Museum of Modern Art, New York
Design and composition by Gina Rossi
Production by Christopher Zichello
Printed and bound by Euro Grafica SpA
Type set in Emigre Cholla Sans and Bembo
Printed on Biberest Allegro 170 gsm

Printed in Italy

Published by The Museum of Modern Art
11 West 53 Street, New York, New York 10019
www.moma.org
Distributed in the United States and Canada
by D.A.P./Distributed Art Publishers, Inc., New York
Distributed outside the United States and Canada
by Thames & Hudson, Ltd., London

Cover: Pipilotti Rist. Detail of *Mutaflor.* 1996. Video installation, dimensions variable. Courtesy Luhring Augustine, New York, and Galerie Hauser & Wirth, Zurich

Frontispiece: Iñigo Manglano-Ovalle. *Nocturne (tulipa obscura).* 2002. Night-vision-enhanced real-time video projection of native Afghan tulip with live audio, dimensions variable. Commissioned by The Museum of Modern Art, New York; courtesy the artist and Max Protetch Gallery, New York

Photograph Credits

Contents

Foreword

Tempo features the work of forty-five contemporary artists from Africa, Asia, Europe, Latin America, and the United States, and inaugurates an ambitious schedule of exhibitions and programs at The Museum of Modern Art's new state-of-the-art facility in Long Island City, Queens. The exhibition endeavors to make manifest many of The Museum of Modern Art's special strengths, including a sustained commitment to present innovative artistic practices of our time without regard to geographic boundaries, a readiness to collaborate with leading and emerging artists to realize complex installations, and a scholarly mandate to formulate thematic exhibitions in addition to monographic and historical assessments of modern art.

While they are connected by a range of shared values and ideas, the artists in *Tempo* probe the intricate web of cultural differences involved in the construction of time. Their work reflects specific local conditions and histories in the making of tangible forms, such as images and objects, resulting in phenomenological, empirical, political, or fictional experiences that explore the physical manifestation of time. The exhibition is divided into five parts: Time Collapsed, Transgressive Bodies, Liquid Time, Trans-Histories, and Mobility/Immobility. Within each section are multimedium installations that include painting, sculpture, photography, sound, video, and performance. Major works from the Museum's collection by artists such as Matthew Barney, Alighiero e Boetti, Vija Celmins, Felix Gonzalez-Torres, On Kawara, Glenn Ligon, Vik Muniz, Gabriel Orozco, and Hiroshi Sugimoto are exhibited alongside works borrowed from public and private collections around the world, many of which have never been seen before in New York. The Museum has also commissioned new installations for *Tempo* from artists Marc Latamie, Iñigo Manglano-Ovalle, Nadine Robinson, Fatimah Tuggar, Kara Walker, and Erwin Wurm.

On behalf of the Trustees, I would like to express my deepest appreciation to the artists for their significant contributions to the exhibition and to the lenders for their generosity. Warmest recognition is owed the many members of the Museum's staff whose efforts ensured the successful completion of this project at MoMA QNS. In particular, I would like to acknowledge the expertise of Paulo Herkenhoff, the curator of the exhibition, who worked with intelligence and enthusiasm with curatorial assistants Miriam Basilio and Roxana Marcoci to bring the exhibition and catalogue to realization.

The exhibition is suppported by Philip Morris Companies Inc. and by Agnes Gund and Daniel Shapiro and The Contemporary Arts Council. The accompanying educational programs are made possible by BNP Paribas. We owe a debt of gratitude to these donors for their unwavering commitment to the presentation of contemporary art to a wide public audience.

Glenn D. Lowry, Director
The Museum of Modern Art, New York

Introduction

As we begin the twenty-first century, the complexity and vastness of the issue of time in contemporary art have expanded substantially along with the increasing variation in art mediums and practices. The exhibition *Tempo,* for which this publication serves as a catalogue, attempts to address the way in which contemporary artists are incorporating temporal images and issues in their art through frames of reference regarding machines, the body, history, symbolism, and quotidian experience. While other exhibitions about time have showed a variety of curatorial approaches, *Tempo* specifically dislocates the classic issues of iconography and theme in order to emphasize the experiential aspects of time, as viewers engage in the itinerary of the exhibition. The exhibition focuses on distinct perceptions of time that are phenomenological, empirical, political, physiological, and fictional; and it includes works by contemporary artists from Africa, Asia, Europe, Latin America, and the United States. The presentation is arranged in five areas that essentially examine cultural differences in the construction of time. This volume is organized in a similar manner.

In the first area, Time Collapsed, the systemic and the random, action and stasis, are interwoven in a cacophony of clocks, watches, and metronomes that seek to destabilize empirical perceptions of time. The second, Transgressive Bodies, probes the physiological processes and libidinal transgressions exercised by the body in time. The physical world involves a sense of continuity and primeval intuition, rather than measurement, but it also includes entropy and transience. In a third section, Liquid Time, the flow of time is explored through representations of water. The fourth grouping, Trans-Histories, considers issues of postcolonialism involving the critical perception of the present through memory. The concept of *diaspora* is addressed in a discussion of time,

narrative, and the marginalization of populations. The complexities of the Greek philosopher Zeno of Elea's paradoxes, based on difficulties of analysis of the continuum (once you have reached an end point you have already surpassed it, and so on *ad infinitum*), are considered in the fifth area, Mobility/Immobility. Aspects of circularity, unending duration, and arrested time are experienced in this last section.

In the catalogue, the choice of an alphabetical lexical format for the texts was partly driven by a desire to disrupt the synchronicity of the usual run of essays on an exhibition related to time. Each entry is constructed within a small frame, and provides a distinct vantage point in the articulation of the issues around which the exhibition is organized and the resultant unexpected relationships among artists and individual works. This nonlinear arrangement of entries establishes cross-references among the various sections, concepts, artists, and works. The lexicon incorporates several curatorial perspectives, mirroring the collaborative process through which the exhibition evolved. Both the exhibition and the catalogue propose a nonlinear configuration, continuously shifting the experience of time.

The artists comprise a varied international group, whose art in many mediums addresses temporal perspectives and cultural issues; their concerns and proposals are discussed with the work of the cultural historian Homi K. Bhabha in mind. Specifically, his linguistic construct (in his book *The Location of Culture*) opposing the words *negotiation* and *negation,* which is intended "to convey a temporality that makes it possible to conceive of the articulation of antagonistic or contradictory elements: a dialectic without the emergence of a theological or transcendent History," has informed much of the preparatory work of the exhibition.

—*Paulo Herkenhoff*

Within this listing of terms relating to the Tempo *exhibition are brief thematic texts that discuss the artists and the works of art in this volume. Specific references to art works illustrated in the plate section are cross referenced by page. Authorship of the texts is indicated at the end of the entries by the initials of the writers: Miriam Basilio (M. B.), Paulo Herkenhoff (P. H.), and Roxana Marcoci (R. M.).*

A Tempo Lexicon

agency: Many artists are committed to revealing the injustices of history. They take on the challenges posed by misleading utopian and idealist views of history, and are motivated by the desire to act as agents of historical change. Their belief in the power of the imagination is crucial to their art, in order, in the words of the scholar Cornel West, "to keep alive the idea of a revolutionary future, a better future different from the deplorable present, a state of affairs in which the multifaceted oppression of Afro-Americans (and others) is, if not eliminated, alleviated." (Cornel West, *Philosophy, Politics, and Power: An Afro-American Perspective in African Philosophy*, 1998.)

Kara Walker's art makes a social investment in the present by reflecting on the historical past. Her operational strategy is to pervert the theatrical possibilities of visual language and its layers of memory, ideology, news, etc., in order to use the knowledge of history as a critique of the present, as in her site-specific silhouettes, part of the series titled *The Emancipation Approximation* of 1999 (page 50). She raises the issue that the function of artistic practice is not to tell stories but to create devices through which history can be told and the present reframed. By uttering the unutterable, by making visible and transparent what was submerged in opacity, and by going beyond difficulty to call forth, to name, and to make present the cultural realities of artists of African descent as well as their subjective acts of resistance, Walker evokes both the pain of the historical record and the urgency of acting to transform the present.

The Angolan video artist Fernando Alvim, by obtaining the loan of a military airplane for a day to film *Blending Emotions* of 1997–99 (page 49), sensed that this could momentarily interrupt the civil war in his country. He remarked: "I stopped the war for a day."

Iñigo Manglano-Ovalle uses complex optical devices, such as military night-vision lenses, to give visibility to what is hidden in games of power, in mastering the knowledge of facts, and in the opaque conflations of media news and recent history. In his installation *Nocturne (tulipa obscura)* of 2002 (page 47) he brings the viewer close to the omnipotent gaze of the devouring capitalist machine by bringing in a black tulip from Afghanistan and confronting that viewer as a passive witness to the movement of war machines and global strategies, communicating a new, unitary flow of time.

A rather trivial fact in the course of José Alejandro Restrepo's visual thinking in the *Amazon Triptych* of 1994 (page 48)—the difficulty of getting out of a hammock—stands for the real difficulty of getting out of ideology. It is Restrepo's allusion to the process of critical knowledge, which he depicts via three videos. "The difficulty is getting out there; because it is like the spiderweb that traps you: like an ideology," he explains. It is the act of observing, which, when imprisoned by the veil of ideology, behaves like the viscous threads of the spiderweb. For the artist, the challenge of entrapment is best handled by the precise knowledge of how to get out of the metaphorical web without tearing it.—P. H.

anachronism: The American artist Glenn Ligon explores "how an individual's identity is inextricable from the way one is positioned in the culture, from the ways people see you, from historical and political contexts." (Thelma Golden, "Interview with Glenn Ligon, Brooklyn, New York, July 11, 1997," in *Glenn Ligon*, Samuel P. Harn Museum of Art, 1997.) He does this in a series of contemporary portraits created, paradoxically, with a repertoire of images dating from the pre-emancipation era. The images, which include typography, were drawn from advertisements in nineteenth-century newspapers calling for the capture of runaway slaves. For the portfolio *Runaways* of 1993 (page 51), Ligon commissioned written descriptions of himself from friends, each of which begins with the phrase: "Ran away, Glenn." In a related series of etchings titled *Narratives (Black Like Me or The Authentic Narrative of Glenn Ligon…)* of the same year, the artist appropriated narrative conventions and imagery used in nineteenth-century accounts in the words of escaped slaves. In both series, the tension between the anachronistic format and the recognizably contemporary person depicted raises the issue of the persistence of racial categories linked to the history of slavery.

The texts accompanying the vignettes in *Runaways* depict a contemporary individual in the context of slavery. For example, one of the ten prints is illustrated with a vignette of a kneeling half-clothed and shackled slave, with a legend beneath the figure with the words: "Am I not a man and a brother?" This signals the anachronistic character and ambivalence of the piece by calling to mind the placards and banners carried by protesters during Civil Rights demonstrations of the 1960s. At the same time, the description includes familiar sartorial references, such as "blue jeans" and "African-looking bracelet on arm." A phrase, such as "He's a shortish broad-shouldered black man, pretty dark-skinned, with glasses . . . nice teeth," suggests the historical connotations of the physiognomic terminology of racial hierarchies used to justify slavery. It also evokes contemporary debates regarding the practice of "racial profiling" by law-enforcement authorities. The reiterated and contradictory references to the exact hue of his skin (for example, "pretty dark skinned" and "medium complexion") elicit consideration of the varied perspectives that shape perceptions of race and social class.—M. B.

baroque: The subject of change on both formal and spiritual levels engages artists in many mediums. Gabriel Orozco's *Yielding Stone* of 1992 (page 34), a round volume made of plasticine, has the same

weight as the artist had when it was made. It was conceived as a body responding to external actions and accidents encountered as it was rolled on the ground. The ductility of *Yielding Stone* allows this body to incorporate new marks and forms or absorb other matter: it is a metaphor for the plasticity of the libido and for placing the sculptural volume in the world as a symbolic birth, much as *The Newborn*, by Constantin Brancusi, touches the surface of the world. *Yielding Stone* goes beyond physicality to include psychology and spirituality. It stands metaphorically as a complex self-portrait with endless twists and turns in a permanent state of mutability.

For Adriana Varejão, a method of constructing and reconstructing images into a canvas surface resembling enlarged baroque tiles is not a puzzle but a symbolic commentary on her Brazilian heritage. *Tiles* of 2000 (pages 62-63) is a wall installation of plaster on canvas that does not have a fixed vantage point. The baroque forms of shells, horns, arms, legs, and sensual volutes—forming an eccentric but organic flow of time—are exposed to fractures between the square forms of the individual "tiles," or segments, in the grid, intended as a reference to the rationality of Cubism and mechanical, objective time. In most of her *Tiles* paintings of the late 1990s, the blue surface stands for the skin of the colonial "body." In others, the fractures of the architectural details expose human viscera as embodiments of the effects of slavery and gender status in Brazil. The organic shapes flowing in and out in defiance of the fractures refer to the philosopher Gottfried Wilhelm Leibniz, who claimed that the soul was marked by endless folds; at the same time, in Portuguese colonies such as Brazil, the existence of a soul was denied slaves and natives. The scale is such that the viewer seems to be inside the installation, where images fold, unfold, and refold continuously.—P. H.

capital: The pragmatic perspective of capitalism is usually expressed as *time is money*. Referring to existence rather than finance, the nonagenarian artist Louise Bourgeois has said, "I try not to waste time. It is a supreme value because it [life] is short." Labor and time are intertwined. A runaway slave is lost capital, the dispersion of labor as Glenn Ligon would argue. Karl Marx wrote: "The utility of a thing makes it a use value. But this utility is not a thing of air. A thing can be a use value, without having value. This is the case whenever its utility to man is not due to labor. Such are air, virgin soil, natural meadows, etc. A thing can be useful, and the product of human labor, without being a commodity." (Karl Marx, *Capital: A Critique of Political Economy*, trans. 1967.)

Cildo Meireles has developed a metrological system that includes a Zero cent coin and a Zero dollar bill illustrated with the image of Uncle Sam, a ruler with mixed numbers and disparate spaces, and clocks with disorderly positions for the numbers, such as *Fontes* of 1992 (page 26). Meireles's subject is the irrationality of capitalism, which he believes creates a disrupted present (the impossibility of measuring capital or labor), future (the infertile investment of Zero dollars), and past (the uselessness of accumulating Zero dollar bills).

And for the French artist Jean-Luc Vilmouth, time for living is associated in his installation *Local Time* of 1987–89 (page 23) with a particular place and with the discipline of labor: a hammer and a clock are paired to indicate the flow of time and energy. The systematic spatial organization of the pairs of clocks and hammers could be interpreted as an international division of labor and the global processes of production, distribution, and appropriation.—P. H.

changing places: The changing place of things in the world led Cildo Meireles to develop a concept of time as place: "The juggler is a synthesis of the image of a fluid territory . . . someone who administers three objects in the territory for just two. In such cases, we have to introduce the concept of time. The juggler is that one who finds a place in time."

The character of the video performances of Michel Groisman does not lie in speed but rather in the juxtaposition of logic and absurdity. In *Weaveair* of 2000 (page 67), in order to extrapolate a geometry around his body through the reflection of a laser ray in mirror devices that are actually sculptures, Groisman has to prepare himself. He has to find the "geometry of anatomy," in much the same way as a magician's assistant must adapt herself within the box that is to be sawed in half.—P. H.

deceleration: Declaring that the modern world was premised on acceleration, velocity, and high-speed systems, avant-garde artists during the first decades of the twentieth century, particularly the Italian Futurists, celebrated the automobile, the motion picture, the airplane, and the industrial assembly line in a single voice. Since then, modernism's cult of instantaneous time has been replaced by more layered, often more analytic, references to temporality. These allude to deceleration, immobility, and slow-motion rhythms. Watching a Ceal Floyer video, focusing on a Douglas Gordon altered-speed projection, or looking at a Hiroshi Sugimoto photograph, requires a modified attentive state in which perception and memory perform unequivocally in the experience of the work.

Floyer's *Ink on Paper* of 1999 (page 72), a video that seems to stand still, is in fact a loop of interminable duration. The image shows the artist's hand holding a black marking pen against a white sheet of paper. Over the course of one hour, the pen imperceptibly leaks its ink, leaving a perfect circular pool in the paper. Surprisingly, even though the ink is spilled out in real time, the pace at which the action unfolds is of such extreme slowness that it is futile to try recording the increments by which the circle expands. In this case, deceleration abolishes the notion of time as change.

Gordon's *Monument to X* of 1998 (page 66) is a projection of a long, passionate kiss made epic by virtue of its length. The footage includes documentation of the kiss, which lasts fourteen hours. Gordon's idiosyncratic approach to time takes its cue from Andy Warhol's films of the early 1960s, such as *Sleep* (5 hours, 20 minutes) or *Empire* (8 hours, 5 minutes). In an earlier video, *24 Hours Psycho,* Gordon turns mobility into immobility by slowing down Alfred Hitchcock's famous film *Psycho* so that its projection lasts fifteen times longer than its original 96 minutes. The intense, anxiety-filled shower scene in the Bates Motel, for instance, goes on for nearly half an hour in an excruciating

frame-by-frame extension. Viewers experience a shift from the rapid flow of moving images to that of autonomous freeze-frame *tableaux*. Time is experienced not as sequential but as prolonged presence. Even more attenuated is a related project titled *5 Year Drive-By*, conceived for a projection of John Ford's film *The Searchers* that lasts five years, the amount of time depicted in the film for John Wayne to search for his abducted niece. In all of these works, the viewer becomes fascinated with the minimal, infinitely slow shots, and with the "eternity of the moment" in which anything seldom happens.

The photographer Sugimoto, although dealing with the primary medium for recording reality at a given point in time, also uses long exposures to question the assumption that what gets recorded by the camera is even a moment at all. In his photographic series *Interior Theaters* (page 76) and *Drive-In Theaters* of the 1990s, he left the aperture of the camera open for the duration of the film screening; and the result is that the fast-moving image is erased. What remains is just a luminous white screen. The decelerated temporality of Sugimoto's pictures—like the videos of Floyer and Gordon—proposes distinct models of recording reality that probe the conventions of both cinema and photography, by conjugating time as indefinite duration.—R. M.

duration:
The avant-garde composer John Cage maintained, as early as the 1950s, that duration, not harmony, defines the structure of music. He justified this by noting that silence cannot be heard in terms of harmony, but only in terms of time. His famous composition *4' 33"*, first performed in 1953, consisted of the pianist David Tudor lifting the lid of the piano and sitting in front of it for the duration of the piece—four minutes and thirty-three seconds—without playing. The ambient sounds, including the noises of an increasingly restless audience, comprised the music. Cage's ideas about duration had a lasting effect for music and other time-based art mediums like film, video, and performance.

In the early 1990s Martin Creed formed the band *owada*, and his first major recording, titled *nothing,* was released a few years later. More systemic and controlled than Cage's randomly composed music, Creed's songs, such as *1-100,* reinvent music by turning the basic rhythmic count "1-2-3-4" into the lyric of the song itself, and then by systemically resuming the count to one hundred. In his installation *Work No. 189. thirty-nine metronomes beating time. one at every speed* of 1998 (page 21) he has crafted an arrangement of thirty-nine mechanical wind-up metronomes, each adjusted to play at one of the metronome's thirty-nine speeds, and each unwinding at a distinct time. Music is thus implied through rhythm, beat, swing, a certain to and fro, and pause. In the earlier *Work No. 97,* a metronome working at moderate speed is played through an amplifier, asserting duration. The beat of the metronome, used by musicians to mark time, rather than actual music, is all that prevails. And in his *Work No. 123,* three classical metronomes tick, one quickly, one slowly, and one neither quickly nor slowly, so that their concerted rhythms collapse the devices' structuring order.

Gabriel Orozco, an artist who has long pondered the notion of duration in relation to perception, has observed: "There could be some kind of resemblance between what I'm doing and John Cage's recordings, but Cage's work has so much to do with chance, whereas I'm really focusing on concentration and intention." As a chess player, Orozco often refers to time-based games, yet invariably subverts their systemic order. A case in point, his piece *Horses Running Endlessly* of 1995 (page 74) takes its vocabulary from the traditional chess game, yet the deviant four-color board with 256 squares—instead of the usual 64—features only knights that move across squares to make a series of circles among themselves. The viewer is invited to enter an implausible situation, lacking a defined set of rules, that is calculated to defer, with each move, the game's logical development. —R. M.

embodied time:
The temporal ideas of clock makers and empirical scientists are Cartesian constructs that measure reality into exact units. One way to circumvent this view is to rethink the agency of the body by considering the antinomies between strict biological time and the body's libidinal experience of duration in which time becomes uncontrollable and fluid. The condition of the body giving itself over to a drive is an important aspect of some of the most interesting work made by Janine Antoni, Matthew Barney, and Pipilotti Rist.

Rist's video installations exude a fascination with erotic desire and unbound time. This explains her frequent use of jump cuts, dissolves, and manipulated soundtracks, which capture the undertow of bodily senses. *Mutaflor*, a video projection of 1996 (page 37), focuses on the body's metabolic processes and elusive internal energies. Sitting naked on the ground in an empty room, surrounded by oranges, limes, and croissants, the artist gazes at the camera, opens her mouth, and the lens zooms in. This is followed by a cut, and an instant later the image zooms out from her dilating rectum. This playful back-and-forth passage from mouth to anus is intended to mark erotic pursuits as well as the metabolic desire to consume and expel. The viewer gazes at the naked body, which encodes the notion of voyeurism, yet there is nothing voyeuristic about *Mutaflor*. By projecting the video image directly on the floor, Rist reorients the viewer's gaze first downward and then into the digestive tract of her own body. In her later work *Extremities (Smooth, Smooth)*, a four-projector three-monitor piece, the space of the projection is transformed into a galaxy of revolving body parts—mouths, breasts, feet, penises, ears—that resists any specific identity.

While Rist deals with unconscious drives, Barney treats the body as a malleable, structurally modifiable field that can be turned inside out and worked upon to transgress its own limits. Interlocking the experiences of athletic training and technological streamlining with the psychology of self-imposed discipline, Barney presents the body as a force without form but of infinite possibilities. His operatic five-part film cycle, *Cremaster,* dramatizes the desire to escape from any form of temporal, spatial, social, behavioral, or sexual constraint and, moreover, from the Freudian contention that biology is destiny. Barney's photographic and sculptural production makes reference to athletics and fashion, two disciplines that promote the image of the redesigned body. His *Pace Car for the Hubris Pill* of 1991 (page 41) is a blocking sled used in football training, made of inorganic prosthetic compounds such as lubricant, glucose, and sucrose—all substances used in the build-up of the athletic body. Pendant to the sculpture is a plastic-framed

photograph (page 40) of a woman dressed in a fashionable 1940s swim-suit, robe, bathing cap, and goggles, posing next to the training equip-ment, which also served as a prop in a videotaped performance. The woman, however, turns out to be a man, and not a model but a beauty queen, epitomizing at once two physical ideals. In defiance of physical limits, Barney's work taps into the psychologically charged terrain of sexual differentiation, where the urge to embody both genders, or a hybrid, dramatizes the desire to exceed the human condition.

Antoni's work also explores the body's limitations and pushes it to physical extremes. But *Wean* of 1990 (page 32), which Antoni describes as her first "breakthrough in thinking about the body," is not so much about the body per se as about bodily absence. It is, first, about the stages of separation from the maternal body and, second, about the distancing from one's own body as one enters the cultural world. *Wean* consists of a series of negative imprints in a wall: forms of the artist's breast, her nipple, three latex nipples used for baby bottles, and finally the molded packaging from the latex nipples. The sequencing from natural to artificial form, or to a prosthetic surrogate, follows the course through which substitution takes place, from oral desire and the nurturing pleasure of sucking of infancy to the oral power of speech, signifying the entry into society. Thus, the body for Antoni becomes an instrument that can register time, from preoedipal stages of psychic development through being weaned.—R. M.

endlessness: The desire for endlessness is incompatible with the paths of life and the universe. Endlessness has become a dream of immortality in advanced capitalist society, whether through medical science, prosthe-sis, gymnastics, or proposals involving bionic, or post-human, anatomy. Damien Hirst represents biological anatomy with images of drug cab-inets, some of which are made to resemble the human body, with medicines for the head in the upper shelf and those for the legs and feet in the lower. One of his drug cabinets, *Liar* of 1989 (page 36), uses drugs to represent the human anatomy as well as to provide a com-mentary on immortality, which they perhaps claim to make possible.

The conflict between permanence and impermanence, finitude and infinitude, emerges in Rebecca Horn's *Thermometer of Love* of 1985 (page 38), which provides an image for the measuring of such feelings as vulnerability and lack of endurance. And these also might be read into the *Rotating Circle* of 1988 (page 70) by Charles Ray, whose endless rotation could be a record on a record player or a camera rolling meaninglessly. The accelerated mobility of Ray's work is perceived as immobility; it rotates intensely, surpassing the capacity of the human eye to perceive its movement. Paradoxically, to speed it up is to produce stillness.

In Angelika Middendorf's video piece *Outer Space* of 1999 (page 65), the incessant intense movement of a swimmer who never advances is experienced as stillness, as she swims against a stream in a training pool. It is, once again, an apparent collision of notions of time, space, and movement. Every expenditure of energy seems to produce immobility, a quality described by Jorge Luis Borges as the capacity to remain in the same place all the time. In Middendorf's video the roles do not follow mechanics: the straight time of linearity in cinema becomes circular, a pool becomes a river; for a moment, eternity is within our gaze.

The world, perpetually rolling about, upside down, and losing sta-bility and purpose, can be experienced in the video *Forever* of 1994 (pages 68–69) by the Chinese artist Zhu Jia, who establishes ambigui-ties between mobility and immobility through paradoxical tensions between the logic of the image and the actual perception of move-ment. Guillermo Kuitca ironically tags an image of a deserted luggage carousel, symbolically and formally endless, with the title of his paint-ing, *Terminal* of 2000 (page 77), which itself indicates an end to time. The artist has said that he thinks of the machine, the airport's conveyor belt, as something endless that cannot sleep, which, like time, moves around and around beyond usefulness and recognition of the presence of anything beyond it.

The work of Nadine Robinson carries these themes forward in terms of social realities through her musical installation, which uses the music of black prison inmates who sing a work chant in which they wish time could stop in order to interrupt their unbearable suffering under the yoke of heavy forced labor. In *Tower Hollers* of 2002 (page 43), she brings out the collective fate of generations of African Americans endlessly limited by past and present class and ethnic discrimination. The installation, which relates music and labor, was conceived during the period of her studio program, World Views, at one of the towers of the World Trade Center. The artist's original concept was to deal with the working conditions of African Americans, Latinos, and European immigrants in the 455 tenant firms that occupied the building at the time. For *Tower Hollers* Robinson mixed two incompatible songs: *Go Down, Ol' Hannah*, a work holler sung by James (Iron Head) Parker, and *Diane (I'm in Heaven When I See You Smile)*, from *Music for Dining*, an album aimed at stimulating productivity in the working environment. The latter refers to Muzak or so-called elevator music; the musical tempos of the holler and the ambient music are conflicting, but both were made for labor administration. The viewer observes the move-ment of the 33-rpm records in *Tower Hollers*, as the work holler addresses the sun: "Go down, ol' Hannah, doncha rise no mo', Go down, ol' Hannah, doncha rise no mo', Ef you rise de mornin', bring Judgment Day." The record players are symbolic of the towers, which represented the social immobility and endless struggle of the working class in the world economy. Recent history has transformed *Tower Hollers* into an unexpected tribute to the victims of the World Trade Center disaster.—P. H.

flux: For Norma Jeane, the transformation of materials makes the processes of life and death palpable. The artist's *Potlatch n. 6.1/The Happy Surrender* of 2001 (page 33) includes cheese made with breast milk, and *To Die For* of 2001 (page 39) incorporates a menacing acid. *To Die For*, a matched set of jewelry (necklaces and ring), was created with the Genovese designer Paola Frusteri and made only with Pyrex glass, which is usually used for chemicals. The insides of the jewels are filled with liquid and colorless sulfuric acid ($H_2 SO_4$) at a high con-centration (98%). Norma Jeane explains that when sulfuric acid mixes with water, considerable heat is released. If not properly handled, the

added water may achieve temperatures beyond its boiling point (340° C or 644° F). The formation of steam inside the jewels, while they were being made, could have blown the acid out of its container. The difficulty lies in keeping such jewelry. The plan to transport the jewelry from Italy to New York required a Teflon container, the only material known to the artist that can hold the acid without being affected by it. The artist makes clear that *To Die For* is a dream about beauty, danger, and desire: "I substitute the economic value ordinarily associated with jewelry for a currency of danger implicit in the object." The elegant and fluent forms of Norma Jeane's jewels entice desire. Crystalline and obscure, the object of desire plays with the instinct of possession. Jewels are weapons of seduction. The glass is thin; if broken, it can hurt or even kill with the sulfuric acid, a strongly corrosive element. The rich and perfect panoply of the body allows beauty to play with the instincts of death.—P. H.

freedom: The quest for freedom is frequently a response to the necessities of today's society, called by the German sociologist Ulrich Beck, the "risk society," in which social institutions once thought to insure our safety also exercise excessive power over our time. Rather than unequivocally conforming to traditional social norms, contemporary individuals opt instead for alternative, more fluid and entrepreneurial lifestyles and devise new ways of reinventing the self.

In the mid-1990s Andrea Zittel developed the series of *A-Z Travel Trailer Units*, living units on wheels designed to offer greater individual freedom through privacy, flexibility, mobility, and even escape. Five years later, she experimented with the *A-Z Timeless Chamber*, one week of living and performing daily activities outside structured time in a space without clocks, sunlight, any sounds from the outside world, or other time devices.

Drawing from her experiments with living units, in *A-Z Time Trials* of 1999 (page 22), Zittel manipulates the construct of time, from predetermination to free will, in an attempt to distend the scope of deep-rooted behavioral patterns. Several octagonal clocks sport customized numerical systems that short-circuit the image of standard time. Although Zittel challenges scientific postulates, the question remains as to whether such experiments offer a sufficient margin of freedom from canonical time structures; they seem to do this, but it should be noted that in the end they become the actual ground for new standards. This was pointed out by the French mathematician and physicist Henri Jules Poincaré in his book *Science and Hypothesis* (1902), where he explained that any standard is a relative model and the result of conventions.—R. M.

horology: The juxtaposition of clocks and other time-related mechanisms by different artists collapses ordinary experiences of time. Accuracy, uniformity, counting, measurement, constancy, and convention collapse, exposing the lived experience of time as a multiplication of difficult passages, or aporias. The viewer might experience feelings of *hors du temps, zeitlos, destiempo,* timelessness. In Peter Regli's *Reality Hacking #147* of 1998 (page 19), two clocks have hands that move in opposite directions. Regli subverts our visual configuration of time, as one clock escapes from its proper, clockwise direction.

In Matthew McCaslin's *What, Where, and When?* of 1994 (page 27), a chaotic configuration of electrical fans and clocks marking disparate hours leads the viewer to question fixed notions of time and space. Alighiero e Boetti's work explores relationships of order and disorder. His *Watches* of 1977–94 (page 25) comprises a set of sixteen watches, each with numbers corresponding to a different consecutive year between 1977 and 1994. If watches measured years instead of hours and minutes, then this work would mark the accelerated passage of time.

Louise Bourgeois has drawn the face of a clock marking twenty-four hours in her ink and pencil *Untitled* of 2002 (page 20). On it she has written the words *Restoration, Reparation, Reconciliation,* and declares: "I want to experience the present." She adds: "To forgive in order to forget," an observation on the process of transcending painful memories and feelings. Here she addresses the changing perspectives of time, the past and the future, and privileges the present.

Some artists reveal the limitations of conventions of daily life and the mechanisms that regulate it. Steven Pippin suggests the redundancy of objects that results from technological development in his installation *Fax 69* of 1999 (page 73), consisting of a pair of fax machines continuously faxing each other, using a single loop of paper and transforming it into a Moebius strip. The fax transmissions leave marks on the long sheet of paper, which may also be understood as a diagram of desire, particularly given the work's punning title. Pippin submits devices to apparently nonsensical operations as a strategy to expose their own absurdity as objects and in order to precipitate technological entropy.

In the case of Martin Creed's installation *Work No. 189. thirty-nine metronomes beating time. one at every speed* of 1998 (page 21), a cacophony of metronomes—a reference to the *Indestructible Object* of Man Ray—subverts synchronicity through sound and speed, enhancing the perception of time and of disparate tempi. Some artists deal with "local time" as the excitement of the present. Klaus Rinke's *Albert Einstein! When Does Baden-Baden Stop at this Train?* of 1989–90 (page 24) alludes to a question posed by Einstein. The possibility that emerges from Einstein's apparently incoherent question is the substitution of "local time" for "local place." Relativity is traveling in the *space* of time. Rinke places the viewer in the position of Einstein, while the moving clock now accounts both for the time and the distance traversed.

In *Fontes* of 1992 (page 26) Cildo Meireles articulates four types of imprecise rulers, clocks that articulate either exact or inexact numbers and spaces, and those with numbers in the wrong positions and in mixed sequence. Thousands of such rulers form two spirals that conform to a diagram of the universe. This installation can only measure the limit of the gaze in the face of difference and discontinuity in the world. *Fontes* posits a question: What if the notions of space and time, two major inventions of man to organize the world, were lost?

For Felix Gonzalez-Torres, two clocks set to the same hour create a double occurrence around an adjusted pleasure. His work of 1991 titled *Untitled (Perfect Lovers)* (page 18) attempts to avoid a verbal introduction to defining the attainment of pleasure. The second part of the title is a kind of substitute, suggesting a desire to enunciate, even if

only parenthetically, the contiguous edges of the clocks; but their slightly different hands, a separation between the self and the other, forms an abyss that denies perfection. This condition represents the limits of desire, as Gonzalez-Torres confronts the viewer with a subtle diachronicity.—P. H.

immanence: In the philosophy of Georg Wilhelm Friedrich Hegel, immanence is the key to understanding the principle of logic that governs the world. The universe—time and its counterpart, space— is a self-perpetuating absolute that does not transcend reality but exists through and in it. For art, this means that transcendence and symbolism, which by definition are exterior rather than inherent in reality, are logically excluded from the real.

In the late 1950s in Brazil the artist Lygia Clark set out to rescue subjectivity and the symbolic dimension of art; to dislocate the dominant Hegelian notion of immanent time; and to establish a phenomenological model for art, which she termed *lived duration*. Her works of the 1960s were among the first to propose audience participation in art as necessary for the integral completion of the art work; she made planar structures that required an investment of effort by the viewer to explore their movements, and she proposed that the audience participate in the experience of exploring a topological structure by cutting along a Moebius strip in her work titled *Walking (Caminhando)*. Here and in subsequent pieces of the kind, time is the experience lived by the audience. Displacing the immanence of time from the metaphysical perspective in favor of phenomenology, dreams, and fantasy, she said: "In the immanent act we do not perceive a temporal limit. Past, present, and future become mixed."

The idea for Erwin Wurm was to make an art work that also can be realized by the public without his physical presence: "All my *One Minute Sculptures* can be realized in different times and geographical levels and in different conditions." Wurm offers an emotional deconstruction of time, yet keeps it a meaningful experience of knowledge with humor. For example, his *One Minute Sculpture* of 1997 (page 35) actually "can last only for a very short period of time." Wurm is playing with the joyous experiences of immanent time on the part of the viewer. *One Minute Sculpture*, according to the artist, should not necessarily last one precise minute; it could last more or less than sixty seconds.—P. H.

infinity: Aspirations toward the infinite have often been explored in art. Among the key manifestations of this impulse in the modern period is the spiritual testimonial of Constantin Brancusi. Conjuring up the idea of a visionary column, he executed it in several versions between 1918 and 1938 as the *Endless Column*. Based on the cloning of a single, identical unit, the *Endless Column* had an inherent capacity to shift from base to sculpture to monument. Its serial, generative form could easily be rendered at different lengths and adjusted to different sites. This was part of Brancusi's nomadic methodology: to produce work of timeless quality, yet specific transferability.

Half a century later, the Japanese artist Tatsuo Miyajima explores similar notions of infinity, recurrence, and randomness. But where Brancusi evinced a mythic approach to time, Miyajima has turned to the endless digital time of the computer age. Time functions as the structural framework for all of his light-emitting-diode (LED) and integrated-circuit (IC) installations, produced since the late 1980s. Parts of his investigations address the two basic temporal constructs: linear time based on rationalist views and cyclical time based on the *corsi e ricorsi* theory developed by the eighteenth-century Italian philosopher Giambattista Vico. The latter is reflected in Miyajima's *Counter Spiral* of 1998 (page 75), a revolving spiral comprising numbers counted forward and back simultaneously from 1 to 99, but never including zero, which would indicate an end. The speeds at which the numbers are changing vary, articulating the relative and indefinite character of time. Temporal relativity, as pioneered by Albert Einstein, is suggested within a single visual zone. Miyajima defines the spiral's endless circulatory movement as a landscape of time, which inscribes within its order both form and entropy.—R. M.

interval: In 1905 a French doctor performed an experiment with the severed head of a guillotined criminal. Following the condemned man's decapitation, the doctor called his name in a loud voice, and the man's eyes opened, fully alive and looking directly at the doctor. Then his eyelids closed. At the doctor's second call, the man's eyes opened once again, staring with a more alert expression than before. Then his eyes shut once and for all. This episode, recorded in the French volume *Archives of Criminal Anthropology,* attempted to find proof of consciousness after death. It lasted between twenty-five and thirty seconds. The artist Douglas Gordon refers to this experiment in his installation *30 Seconds Text* of 1996 (page 29), which consists of a darkened room furnished on one wall with an account of the experiment and a light-bulb set on a timer that goes on and off every thirty seconds. Connecting the sensation of the beheaded body of the criminal to that of the reader of the text, Gordon equates the interval between life and death to the time it takes a person to read the notes on the experiment. Like other works by Gordon, this piece plays with time, the production of suspense, and the process of perception.—R. M.

Janus: In Roman mythology the god Janus has two faces and looks toward the past and the future at the same time. A pendular sculpture by Louise Bourgeois, *Janus Fleuri* of 1968 (page 31), raises issues for the artist related to time and gender: past and future, male and female. She says: "It is necessary to search for the balance between yesterday and tomorrow, since the present escapes me. Janus never looks at the past; he turns his gaze towards the future." The Roman god represents the spirit of gates and doors, of passages and transitions. The sculpture's volume articulates the rational finish of the bronze surface and areas in which the erotic touch in molding is clearly a libidinal investment that is transmitted to the gaze. The bronze material stands for the indestructibility of Janus. Bourgeois detests terracotta because it is breakable and finite. She says: "Time can be represented by dust. You don't clean your books, the dust will gather and you will . . . blow. To gather dust is to negate time. It is to express it." Thus, if dust for Bourgeois is negation of time, wax relates to the malleability of people.

Bourgeois identifies people with art materials: "We are as malleable as wax. Descartes has spoken about wax. We speak about a ball of wax. And consequently, we are also sensitive to the souvenirs of what has happened before and apprehensive as to what is going to happen afterwards. I experiment with people who are like a piece of iron: they are not malleable at all. I have no confidence in my possibilities of manipulating other people."

David Hammons avoids a romantic approach to art materials in art in his *Nap Tapestry* of 1978 (page 30), which deals with transforming the social and concrete truth of the material. Hammons is aware that the material in question is political: nap hair is subject to social prejudice. The artist refers to the situation by incorporating it in his art. If the present is marked by nomadism and apparent elusiveness, *Nap Tapestry* points to the past, to cultural ancestry: "It is the oldest hair in the world." It also points to a future confrontation with racism for the construction of a different society: "Black hair was the only thing then that was not of the oppressor's culture." Thus, *Nap Tapestry* is Hammons's construction of a political Janus.—P. H.

labor: The dehumanizing effects of labor form the powerful subject of the art of Vik Muniz and Marc Latamie, both of whom focus on the sugar trade. Muniz's series *The Sugar Children* of 1996 explores the mechanisms of photographic representation in six portraits of the children of sugar plantation workers in St. Kitts, in the West Indies, which were rendered with sugar. According to Muniz, the cheerful children he had met there would eventually be "transformed by sugar. Children who become sugar," do so through their labor in this industry. The grainy quality of the images, a visual pun on the dots that make up newspaper and magazine photographs, also recalls the process of developing an image on photographic paper. At the same time, the use of sugar leads to reflections about the effects of manual labor and economic inequalities. In contrast to photojournalistic or anthropological conventions, which render workers as types, Muniz translates the material that may eventually consume the children's lives into a medium to render their outlines. The close-up appealing expressions and the titles Muniz has given his images bring to light the particularity of each child's personality: *Valicia Bathes in Sunday Clothes*; *Jacynthe Loves Orange Juice*; and *Valentine, the Fastest* (page 46).

Latamie's installations related to the process through which sugar is produced and traded are based on his research into the historic and economic circuits through which the African slaves who processed sugar crossed the Atlantic. This investigation extends to contemporary market relations and to the relationships of Caribbean people with this product today. In *Casabagass* of 2002 (pages 44-45), the artist brings a shack housing a sugarcane grinder into the museum context, involving visitors in the process of the consumption of sugarcane juice. The amount of sugarcane processed into juice within the installation is based on the amount produced on an average day by a farmer in Fort-de-France, in Latamie's native Martinique. A video of sugarcane fields in flower shot in Martinique also forms part of the shack. *Casabagass* reverses the usual flow of sugar from the Caribbean island sugarcane fields to Wall Street's trading floors, where it becomes an abstract commodity.—M. B.

leisure: Investigating the idea of leisure time, in which natives of wealthy nations intersect with those of "developing" countries, Fatimah Tuggar's video *Meditation on Vacation* of 2002 (page 52) spans the typical Western tourist's trajectory, from arrival to departure. Deploying montage to explore disparities in the effects of globalization, she creates juxtapositions between images of Caribbean vacation venues and local labor, along with images taken in Nigerian towns that underscore the uneven flow of immigration, labor, capital, and tourism. At the airport, for instance, arriving tourists are waved through customs, while cardboard boxes filled with presents brought by returning immigrants are searched. Stereotypical images of a tropical paradise—sailboats, a mother and daughter playing in the sand—are disturbed internally by the incorporation of images of Nigerian dwellings or contiguously by a scene at an outdoor market. Footage of a speech given by Horst Kohler, of the International Monetary Fund, cuts into the flow of images. "The issue is to make globalization work to the benefit of all," he intones. The image of a welcoming hotel room appears. In the voiceover, as in the images, Tuggar employs both her own and appropriated texts. The natives of tourist locales, she says, "envy your own ability to turn their own banality and boredom into a source of pleasure."—M. B.

memory: Commentary on the retroactive character of temporal consciousness in literature is epitomized by the writer Jorge Luis Borges in his story "Funes, el memorioso," where he renders a character paradoxically trapped in the present through the exercise of memory. Following an accident, Funes develops an ability to recall events exactly as they occurred. Recalling a particular day, for instance, would therefore require twenty-four hours. Funes is reduced to exhaustion in his darkened room, as he marvels each time anew at a dog passing by his window, perceiving it as if it was the first time. Funes's ties to language and memory erode as his perpetual present renders him unable to recognize that the word *dog* can apply to an infinite number of such animals: "To think is to forget differences, generalize, make abstractions. In the teeming world of Funes, there were only details, almost immediate in their presence." (Jorge Luis Borges, "Funes, the Memorious," in Donald A. Yates and James E. Irby, eds., *Labyrinths: Selected Stories and Other Writings,* 1964.) Funes's perception recalls the experience of real-time news coverage, in which a viewer is saturated with data and seduced by the illusion of immediacy, which distracts from historical analysis. It is precisely this confusion between lived experience and media images of historic events that is explored by Iñigo Manglano-Ovalle in his video *Nocturne (tulipa obscura)* of 2002 (page 47).—M. B.

postcolonial globalism: The world at large is both more compressed and more fluid, calling paradoxically for ideas of postcolonial migration on the one hand and those of electronic adjacency on the other. Fatimah Tuggar perceptively argues that the world we live in is increasingly subject to mediation although some regions still lack even early

technology, like electricity. She also notes that the power of the mass media is, to a great extent, prevalent everywhere, while the cultural historian Andreas Huyssen has commented on the fact that the globe has been retribalized via television, a sort of contemporary tribal drum. Moving between cultures, Tuggar uses computer montage and video collage to address issues of locality and identity, and irreconcilable Western realities and rural African lifestyles. In *Sibling Rivalry* of 1995 (page 53), for instance, two Nigerian children dressed in traditional garb play with building blocks. Yet, their activity is deceptive; they are shown adjacent to an image of the New York Stock Exchange, and what they actually play with—to politically provocative effect—are Western buildings. Tuggar probes the surreal dislocations triggered by postcolonial migration, which is connected to world economics. She presents non-Western populations fostering links with more than one place, formulating new geographical matrices, and declining to settle in one circumscribed territory. In the end, by debunking stereotypes of diasporic communities, she seems to be calling for the formation of a global order based on the abolition of all coercive systems of representation—whether territorial, religious, racial, or ethnic—that refuse to include intervention by those represented.

Tuned to new digital technologies of representation, Paul Pfeiffer also addresses the construction of sociocultural and postcolonial discourses, especially as articulated in the world of sports. In his video *Goethe's Message to the New Negroes* of 2001–02 (page 71), Pfeiffer takes found NBA footage of black basketball players caught in motion, and re-edits it so that each figure fluidly dissolves into the next. The title of the work is borrowed from the writings of Léopold Sédar Senghor, the first president of Senegal and an acclaimed African poet and intellectual. Senghor moved to France in 1923, where he formed an alliance with the Surrealists and the political Left. He then became a major player in the struggles for African liberation and independent nation building. The artist highlights Senghor's emphasis on black identity and cultural values: drive, endurance, communal spirit, and human emotion. In considering the title of his video, Pfeiffer acknowledges his fascination with Senghor's active stand against both fascism and colonialism in Africa, but explains that there is no single message to be gathered from it. Rather, the title is intended to multiply the tensions and questions already inherent in the video itself.—R. M.

primal scene: Certain traumatizing experiences of childhood, according to Sigmund Freud, constitute the primal scene, by which he meant actual events involving children transformed by them through fantasy and fear into life-defining experiences. Commonly, but not exclusively, these are associated with the sexuality of the parents, either observed or imagined; the child typically interprets an observation of the parents' coitus as a violent scene perpetrated by the father, which can generate a deep haunting anguish. But the self-defining primal scene may be generated by other kinds of events as well.

In the work of Adriana Varejão, the parameters of the primal scene are inserted into history and can involve identity and ethnic origin. In some of her work, Varejão reconstructs an imaginary scene of the origins of Brazil through the colonial process by creating false evidence of the country's interethnic relations, often based on rape. For example, she utilizes generic portraits of men (a priest and an official) by Jean Baptiste Debret to create scenes of the rape of two women, a native and a slave.

Stressing an interest in literature, Kara Walker creates the primal scene as theater. Her intense thought inscribed in her art is meant to echo in the viewer's mind. She speaks in different moods of anger, abandonment, resistance, hesitation, challenge, irony, individuality, and the demands of ethnic identity. Her reconstructions of the primal scene in social terms is a strategy to expose the opaque history of violence against women and African Americans. In her wall installation, *The Emancipation Approximation* of 1999 (page 50), she uses silhouettes to articulate certain appropriated narratives that address issues of race, and attitudes toward women and artists that reduce them to tokens of ethnic and gender-based identity and the unconscious agents of cultural bias. This conflation of fiction and drama results in what Walker calls "an undetermined number of schizophrenic voices" in her works. The experience of time is a distancing game of estrangement and approximation. In her installation, Walker creates contradictory situations about time: "not yet approaching the future," "distance and proximity," the "titillation" of the imaginary reduced to stereotypes, the simplicity of silhouettes, and the absence of detail and nuance in the representation of the characters are all inherent in a disturbing discontinuity of time. The shifting logic and exchange of roles among the personages of *The Emancipation Approximation* recount frictions of history and violence, including sexual violence, the failures of progressivism and modernism, and the brutality of the norm. Walker's work is a theater of shadows projected from the past to enlighten and to define a critical density in the present.—P. H.

real time: The use of the term *real time*, joined to the seemingly redundant *live*, refers to media representations regarded as equivalent to the direct experience of an event. The now-familiar greenish hue of a television screen dissolving into pixels with the word *LIVE* in one corner coincided with unprecedented limits placed on reporters' access to battlegrounds abroad, specifically since the Gulf War, and increased surveillance at home. That war inaugurated a new kind of visual reporting, as state-of-the-art infrared camera technology used by the media and the military encouraged television viewers to have the impression that they were eyewitnesses to breaking news in real time. This is, of course, now familiar in the coverage of the war in Afghanistan, in which relentless emphasis on the present fosters an ahistorical perspective. The technological, temporal, and perceptual links between the presentation of media images as unmediated reality and the transformation of many public spaces into sites of surveillance emerge as the viewer is drawn toward the immediacy promised by the projected image, while becoming a part of it. These issues are explored by Iñigo Manglano-Ovalle, using science and technology to question systems of classification and surveillance in a series of installations since the 1990s. In his night-vision-enhanced real-time video projection *Nocturne (tulipa obscura)* of 2002 (page 47), a camera equipped with motion sensors films a native Afghan tulip. At the same time, the

viewer is incorporated into the work through the process of moving within the darkened space as he or she is drawn toward a projected image of the flower. The experience of the work raises questions about the relationships among representation, perception, time, and space.—M. B.

today: The *Today* series, begun in 1966 by On Kawara as an ongoing, open-ended process, comprises hundreds of canvases. Each consists of the actual date on which the work is executed, together with a box in which are stored newspaper clippings from the same day. Through this pairing, the artist aligns autobiography with world events culled from the news. At first, the titles of these paintings were derived from newspaper headlines. Since 1973 they have been based on the day of the week on which Kawara produced the work. A date painting can only be made on the day of the date depicted in the painting and is inscribed in the language of the country the artist happens to be in at the time. Painstakingly executed by hand, each painting must be completed by midnight of that particular day or else destroyed. The physical passage of time, the eight to twelve hours invested in the act of painting, are considered part of the content of the work. Constructed in the present tense, today's date, each of the date paintings paradoxically refers to a time already past. The viewer experiences the *Today* series as a memorial to that which has occurred.

The concept of time has informed all of Kawara's projects over the past four decades. For example, in 1969 Kawara sent the following three telegrams to the curator Michel Claura in Paris as his contribution to an exhibition: I AM NOT GOING TO COMMIT SUICIDE, DON'T WORRY; I AM NOT GOING TO COMMIT SUICIDE, WORRY; I AM GOING TO SLEEP, FORGET IT. These messages launched the series *I Am Still Alive*; the telegrams and subsequent mailgrams, which Kawara sent to various addressees, bear testimony to his continued existence, to the fact that his death has not yet occurred, and to the evidence that the fact is automatically annulled by the time the message is received. What remains is a document, which has the unity of the present time in the framework of what has been.—R. M.

water: In many ancient cultures water is used to provide an image of time, and in others it is the originating principle that explains all things. For example, the ancient Greek founder of natural philosophy Thales of Miletus, one of Plato's Seven Sages, held that water is the primary substance from which all things were derived, and represented the earth as floating on an underlying ocean. In *A Laundry Woman* of 2000 (page 60), Kim Sooja stands motionless watching the flow of the Yamuna River in Delhi, India, which is named for a Hindu goddess who controls female power, and symbolizes fertility and abundance. The water passes by, carrying flowers and burnt objects from a crematorium. The hydraulic energy of the river and the flight of the birds reflected on its surface lead to the artist's meditation on life and death:

"I was awakened by the fact that it is my body which will be changed, vanished, and disappeared soon . . . but the river is always there." Kim offers the viewer a choice: to be a spectator of her videotaped action or to take her place and watch the river. Her ambivalence echoes the changing flow of the water.

The work of Roni Horn explores her intense focus on time through the fluidity of water in rivers, geysers, and clouds. She analyzes language as she maps water as a paradoxical topology, naming its states of transcience and consigning interpretive footnotes to her images. Horn's work, such as her lithographs *Still Water (The River Thames, For Example)*—*Image B* and *Image L* of 1999 (pages 56-57), exposes tensions between the arrested time of the photographic image of water, the flow of the river as liquid time, and the course of language itself.

For Vija Celmins, a drawing can become the visual embodiment of the ocean: the construction of the image restates the physical, mineral quality of water. Drawing, like water, has a transient character, as the artist's hand glides across the paper. The disciplined gesture of the act of drawing implies that material traces of its passage are left behind. Celmins converts it into a charged presence in the world, as in her Untitled *(Ocean)* of 1970 (page 55). In the *Fulfilled Aquarium* of 1987 (page 59) Waltercio Caldas proposes a paradoxical language and a transparent, fluid imagery underscoring the arbitrary linguistic relation between the signifier and the signified. For him, the opposition of these two poles is merely the schism between use value and exchange value (in Marxist terms). In the work of Caldas, the signifier is adrift.

In Alighiero e Boetti's *Tapestry of the Thousand Longest Rivers of the World* of 1971–79 (page 58) the longest river does not have the longest name, but the names of rivers flow, indicating the fluidity of language. Made in Afghanistan, his tapestries enunciate the contribution of labor, from the so-called undeveloped countries and from traditional cultures, to the exchange value of art. In José Alejandro Restrepo's video work *Amazon Triptych* of 1994 (page 48) a native wears a T-shirt emblazoned with the printed face of a politician, a symbol of power in relation to labor. As he rows a boat, the image of the politician moves. Restrepo quotes how time is implied in the characterization of vision by the people indigenous to the region of the Emba River in Kazakhstan, who say: "Seeing is like the water circles . . . which expand slowly until they become water again."

In Felix Gonzalez-Torres's *Untitled* of 1991 (page 61), a stack of offset lithographs with a photographic image of water on each sheet provides a static image of constant motion, repeated endlessly. The viewer is invited to take one off the pile; in this way the artist introduces actual movement while renouncing his role in the piece from the point in time at which the image is taken away. Thus, the art work continues to circulate its paradoxical meaning: the experience of time depends on the passages taken by individuals. It is never the same twice, or, to paraphrase the Greek philosopher Heraclitus: You cannot step twice into the same river.—P. H.

Plates

1 Time
Collapsed

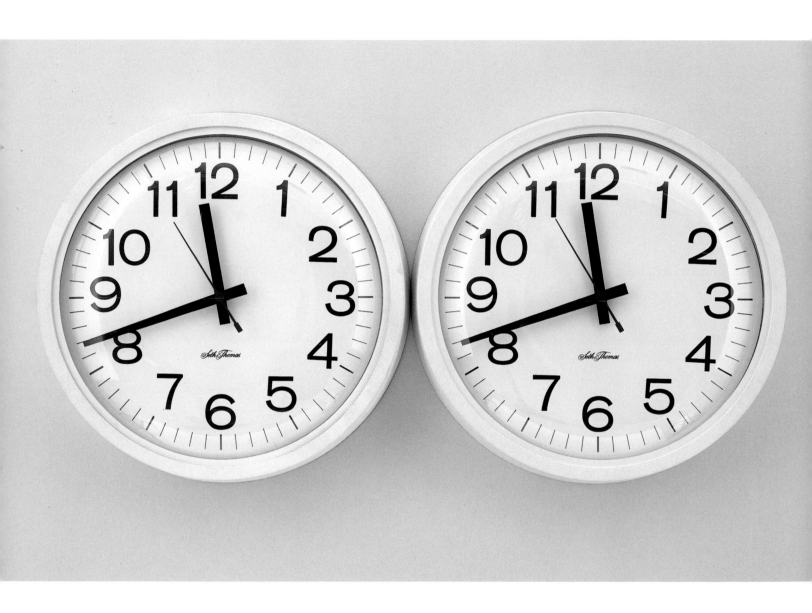

Felix Gonzalez-Torres. American,
born Cuba. 1957–1996
Untitled (Perfect Lovers). 1991
Two clocks, each
14" (35.6 cm) diam. × 2 ¹/₄" (5.7 cm) deep
The Museum of Modern Art,
New York. Gift of the Dannheisser
Foundation

18

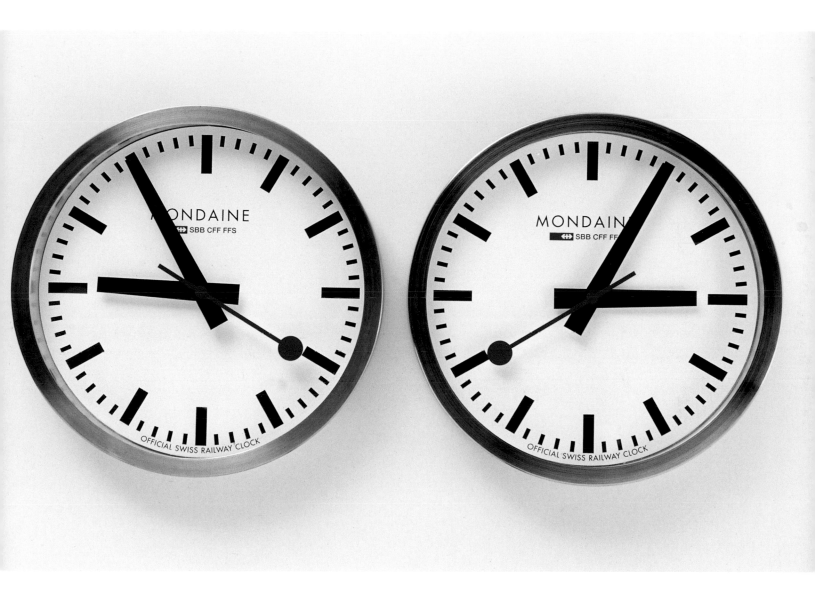

Peter Regli. Swiss, born 1959
Reality Hacking #147 1998
Two wall clocks, each
10 5/8" (27 cm) diam.
Courtesy the artist, Zurich

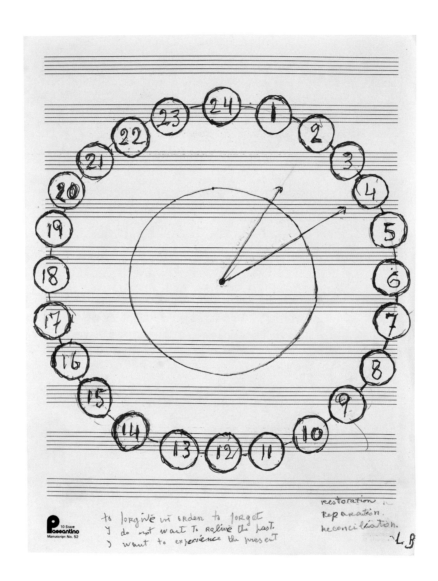

Louise Bourgeois. American,
born France, 1911
Untitled. 2002
Ink and pencil on music paper,
11 ¾ × 9" (29.8 × 22.9 cm)
Collection the artist; courtesy
Cheim and Read, New York

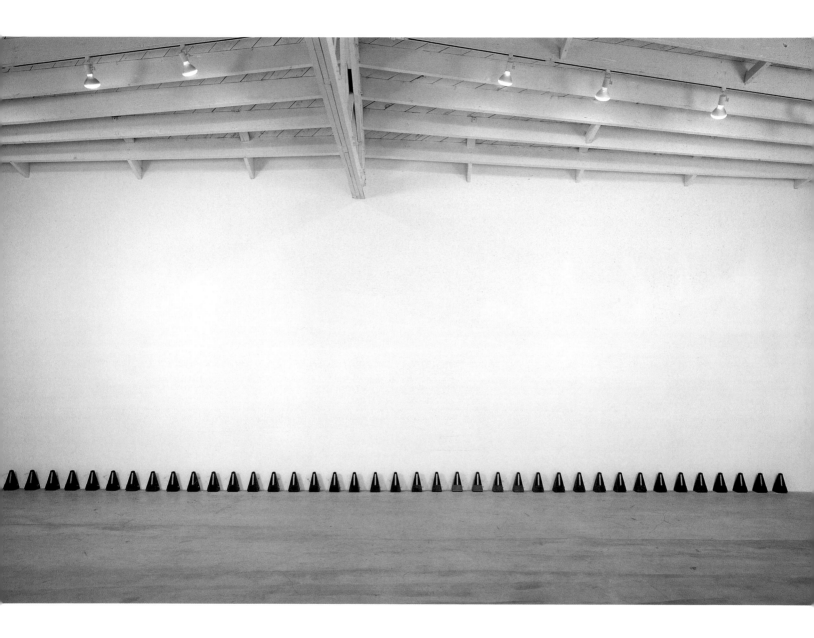

Martin Creed. British, born 1968
Work No. 189. thirty-nine metronomes
beating time. one at every speed. 1998
39 mechanical Malzel metronomes,
each 9 × 4$\frac{1}{2}$ × 4$\frac{1}{2}$" (23 × 11.5 × 11.5 cm);
overall dimensions variable
Private collection; courtesy Gavin
Brown's enterprise, Corp., New York

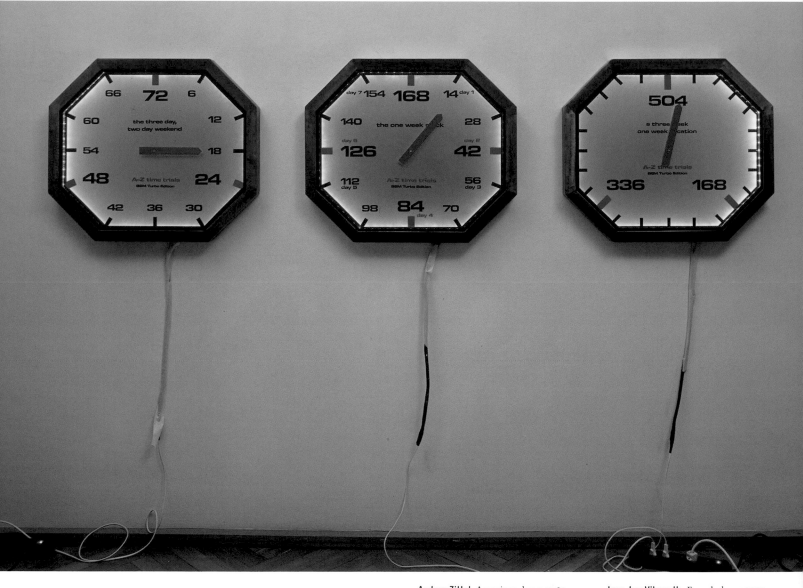

Andrea Zittel. American, born 1965
A-Z Time Trials (detail). 1999
Five clocks, wood and steel frames,
clockworks, and electric motor,
each 26 × 29 ¹⁵/₁₆ × 2 ³/₈" (66 × 76 ×
6 cm); overall dimensions variable
Collection Burton S. Minkoff, Miami;
courtesy Andrea Rosen Gallery,
New York

Jean-Luc Vilmouth. French, born 1952
Local Time (detail). 1987–89
100 wall clocks and 100 hammers,
each clock: 25" (63.5 cm) diam.;
each hammer: 12 ³/₈ × 5 ¹/₂ ×
1 ³/₁₆" (31.5 × 14 × 3 cm)
Collection Caisse des dépôts et
consignations, Mission Mécénat; on
deposit at Musée d'art moderne,
La Terrasse Saint-Étienne

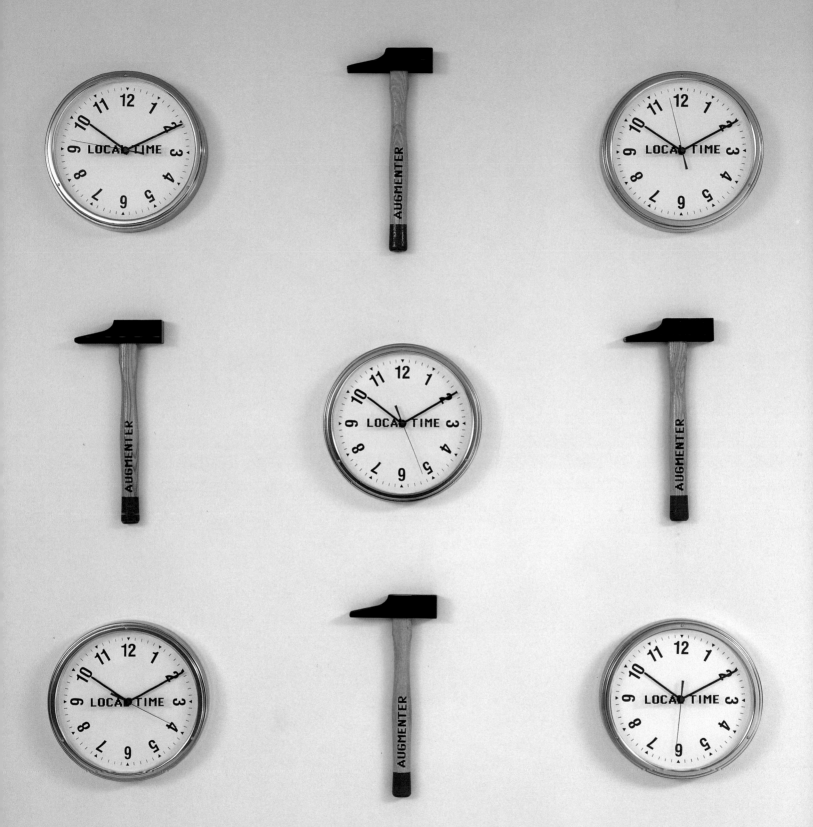

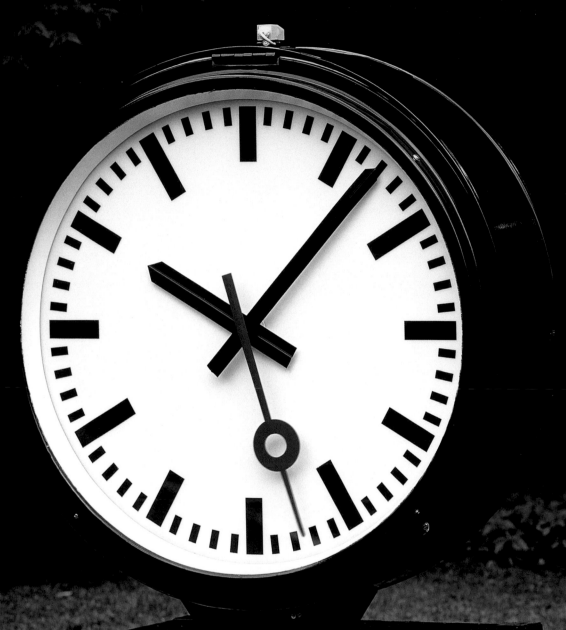

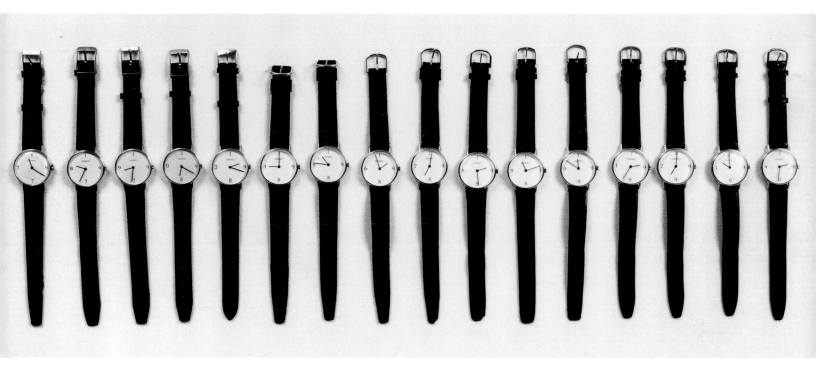

Klaus Rinke. German, born 1939
Albert Einstein! When Does Baden-Baden Stop at this Train? (Albert Einstein! Wann hält Baden-Baden an diesem Zug?). 1989
Clock mounted on base with wheels on rail, clock: 39 3/8" (100 cm) diam.; rail: 19'8 1/2" (600 cm) long
Private collection, Germany

Alighiero e Boetti. Italian, 1940–1994
Watches. 1977–94
16 watches, and leather and glass box (not shown), each watch face: 1 11/16" (4.3 cm) diam.; box: 16 1/8 × 32 11/16" (41 × 83 cm)
Collection Agata Boetti, Paris

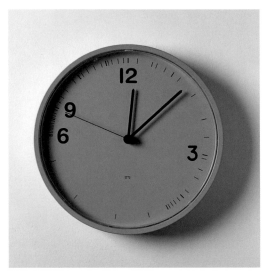

Cildo Meireles. Brazilian, born 1948
Fontes. 1992
Four clocks, each 8⅝" (22 cm) diam.
Courtesy the artist, Rio de Janeiro

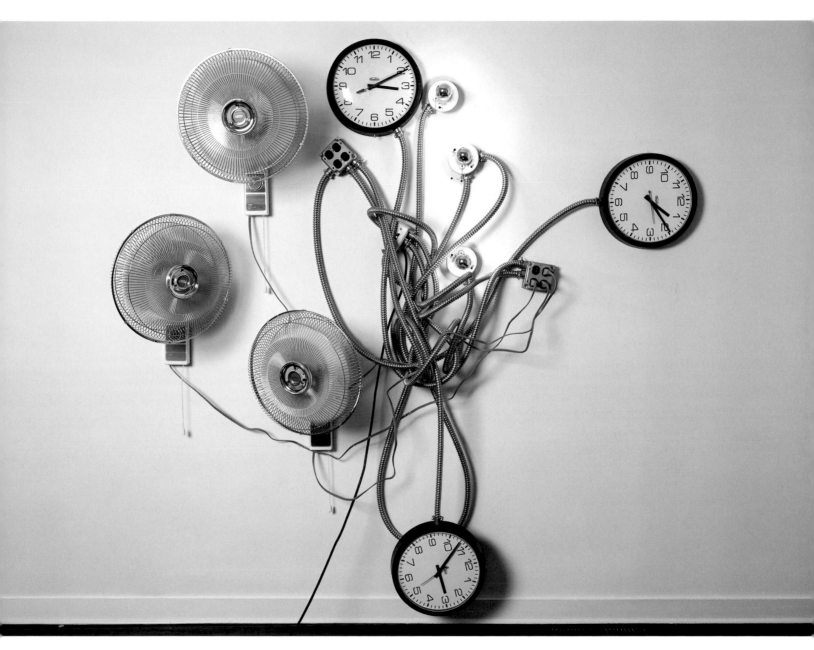

Matthew McCaslin. American, born 1957
What, Where, and When? 1994
Clocks, fans, and industrial electrical
hardware, overall 87 × 87 × 16"
(220 × 220 × 40 cm)
Collection the artist; courtesy Galerie
Evelyne Canus, Paris and Basel,
Shoshana Wayne Gallery, Santa
Monica, Sandra Gering Gallery, and
Feigen Contemporary, New York

2 Transgressive Bodies

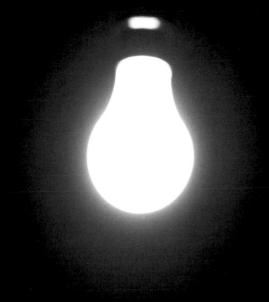

30 seconds text.

In 1905 an experiment was performed in France where a doctor tried to communicate with a condemned man's severed head immediately after the guillotine execution.

"Immediately after the decapitation, the condemned man's eyelids and lips contracted for 5 or 6 seconds…I waited a few seconds and the contractions ceased, the face relaxed, the eyelids closed half-way over the eyeballs so that only the whites of the eyes were visible, exactly like dying or newly deceased people.

At that moment I shouted "Languille" in a loud voice, and I saw that his eye opened slowly and without twitching, the movements were distinct and clear, the look was not dull and empty, the eyes which were fully alive were indisputably looking at me. After a few seconds, the eyelids closed again, slowly and steadily.

I addressed him again. Once more, the eyelids were raised slowly, without contractions, and two undoubtedly alive eyes looked at me attentively with an expression even more piercing than the first time. Then the eyes shut once again. I made a third attempt. No reaction. The whole episode lasted between twenty-five and thirty seconds."

...on average, it should take between twenty-five and thirty seconds to read the above text.

Notes on the experiment between Dr. Baurieux and the criminal Languille (Montpellier, 1905) taken from the Archives d'Anthropologie Criminelle.

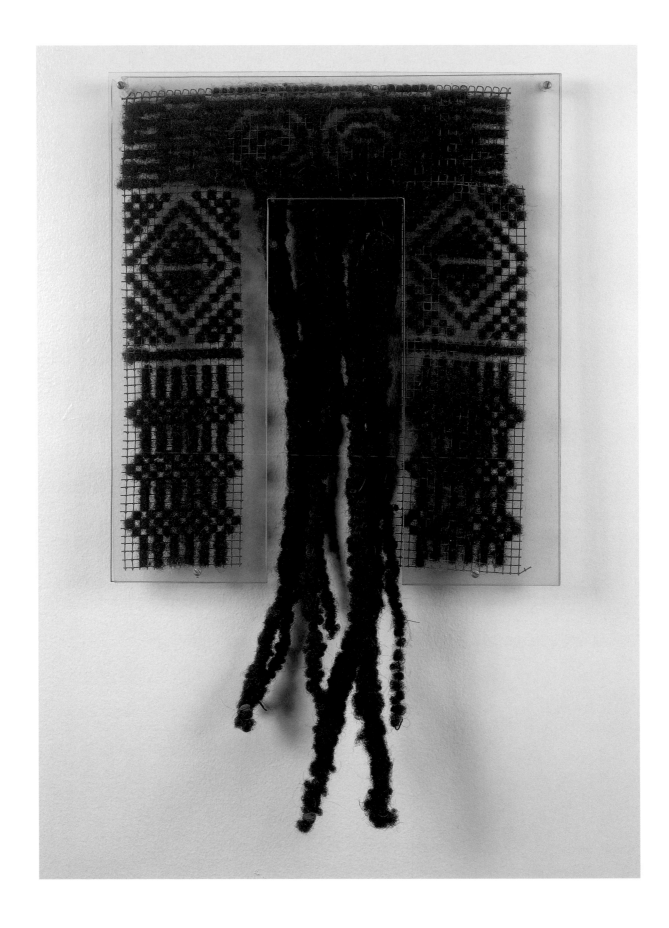

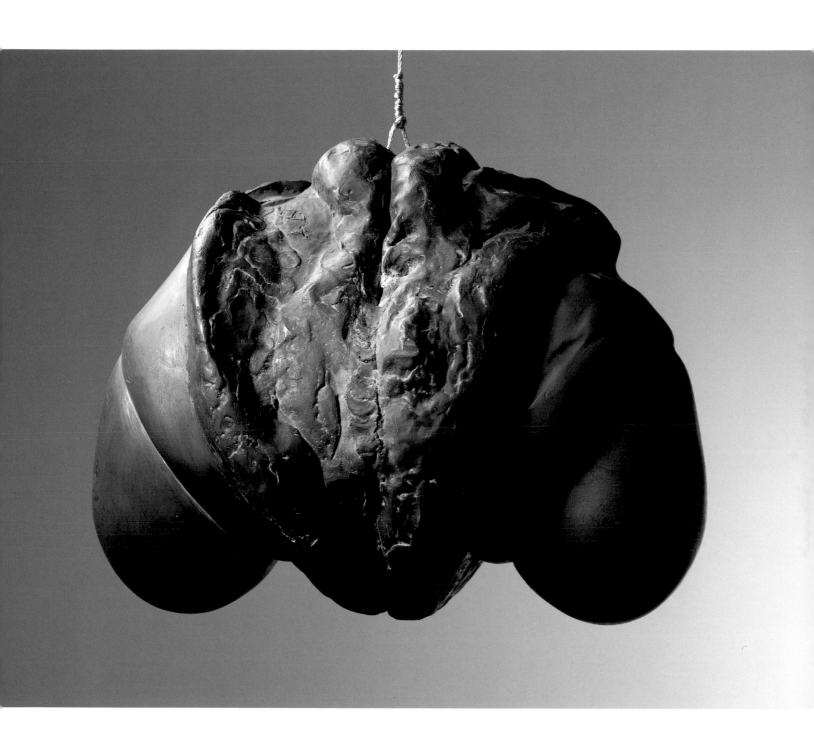

David Hammons. American, born 1943
Nap Tapestry. 1978
Hair and Plexiglas, 23 × 14 × 16"
(58.4 × 35.6 × 40.6 cm)
Collection A. C. Hudgins, Englewood,
New Jersey

Louise Bourgeois. American, born
France, 1911
Janus Fleuri. 1968
Bronze with golden patina, 10 ¹⁄₈ ×
12 ¹⁄₂ × 8 ³⁄₈" (25.7 × 31.7 × 21.2 cm)
Collection the artist; courtesy Cheim
and Read, New York

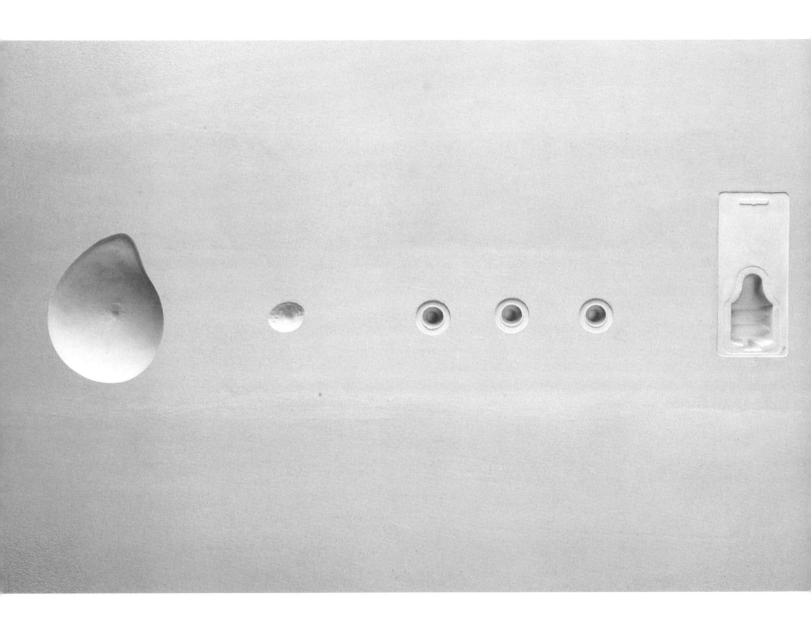

Janine Antoni. American, born
Bahamas, 1964
Wean. 1990
Plaster, 12 × 38 × 2"
(30.5 × 96.5 × 5.1 cm)
Collection Craig Robins; courtesy
Luhring Augustine, New York

Norma Jeane. Italian, born United
States, 1962
Potlach n. 6.1/The Happy Surrender. 2001
Installation: cheese made with breast
milk, cow's milk, rennet, and salt inside
a refrigerator, dimensions variable
Collection the artist, Milan

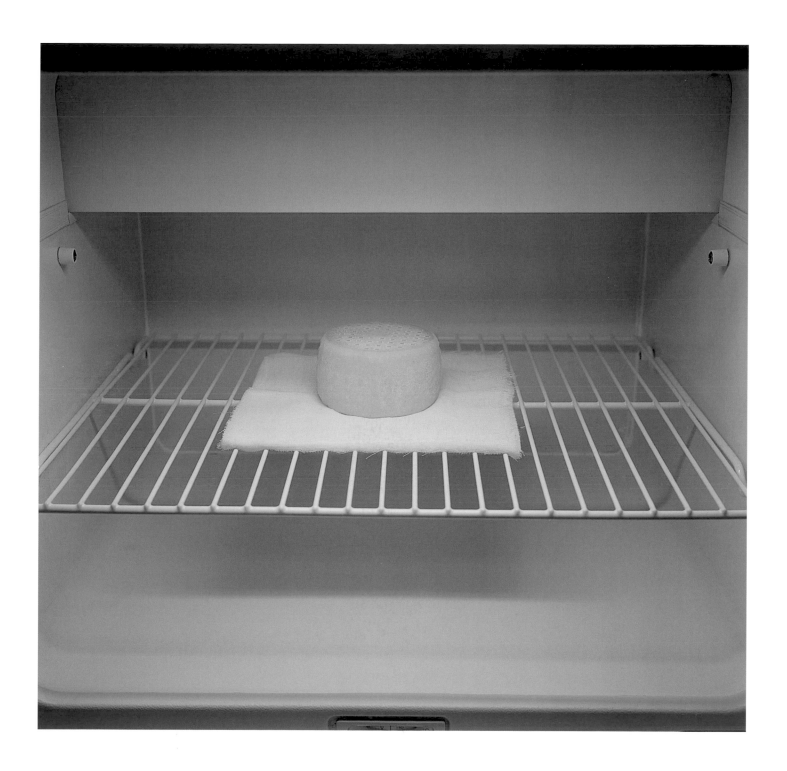

Gabriel Orozco. Mexican, born 1962
Yielding Stone. 1992
Plasticine and debris, 14¹/₂ ×
15¹/₂ × 16" (36.8 × 39.4 cm)
Courtesy the artist and Marian
Goodman Gallery, New York

Erwin Wurm. Austrian, born 1954
One Minute Sculpture. 1997
C-print, 17¹¹/₁₆ × 11¹³/₁₆" (45 × 30 cm)
Courtesy the artist and Art:Concept,
Paris

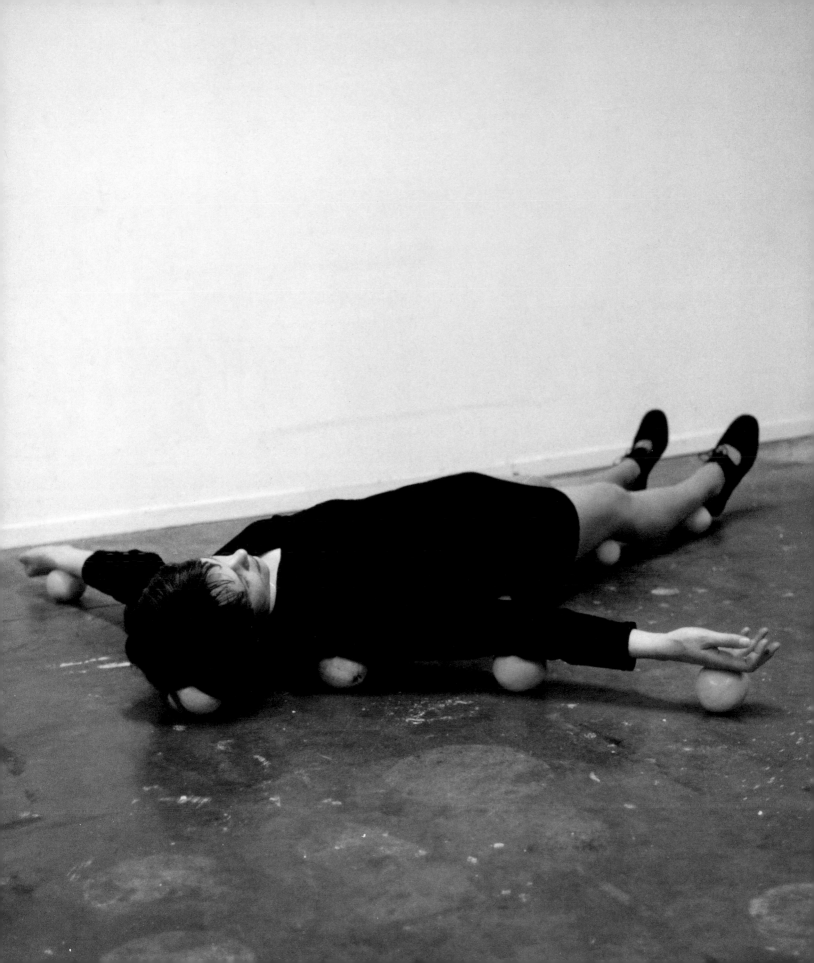

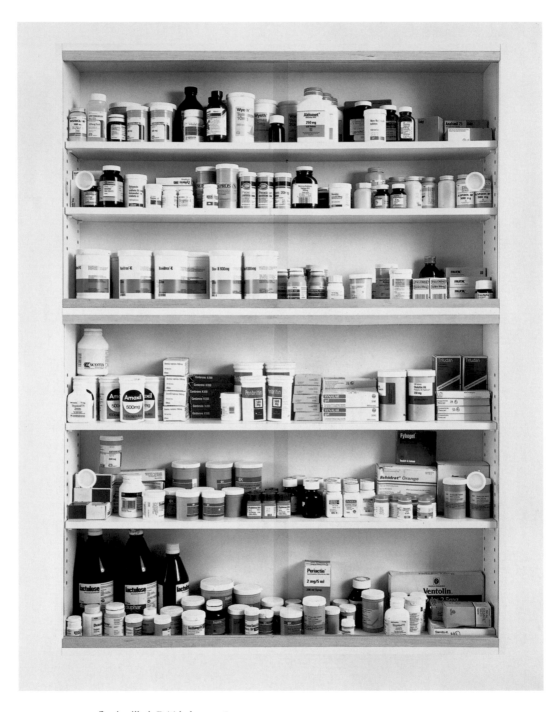

Damien Hirst. British, born 1965
Liar. 1989
Drug packaging and cabinet,
54 × 40 × 9" (137 × 102 × 22 cm)
Collection The Brant Foundation,
Greenwich, Connecticut

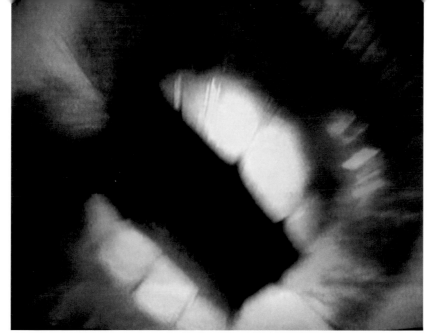

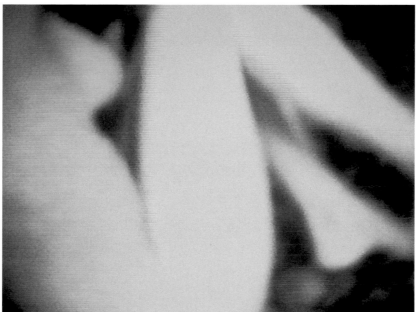

Pipilotti Rist. Swiss, born 1962
Mutaflor. 1996
Stills from video installation,
dimensions variable
Courtesy Luhring Augustine,
New York, and Galerie Hauser &
Wirth, Zurich

S'ABIMER

FOLIE

INSUPPORTABLE

VÉRITÉ

ANGOISSE

GACHER

SIGNES

DÉSIR

ERRANCE

MANQUE

TENDRESSE

RÉVEIL

CORPS DU COEUR

MAGIE

ÉTREINTE

ÉCORCHÉ

NUIT

TOUCHER

IMAGE

ASCÈSE

SOLITUDE

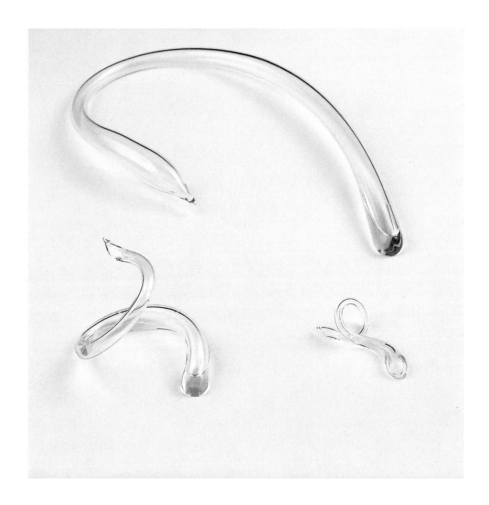

Rebecca Horn. German, born 1944
Thermometer of Love. 1985
Thermometer and heat sensitive fluid,
$34^{1}/_{4} \times 5^{1}/_{8} \times 3^{15}/_{16}$" (87 × 13 × 10 cm)
Courtesy Galerie Thomas Schulte,
Berlin

Norma Jeane. Italian, born United
States, 1962
To Die For. 2001
Pyrex glass filled with sulfuric acid
on Teflon support, $17^{11}/_{16} \times 11^{13}/_{16} \times 1^{15}/_{16}$" (45 × 30 × 5 cm)
Collection Gropello; courtesy the
artist, Milan

39

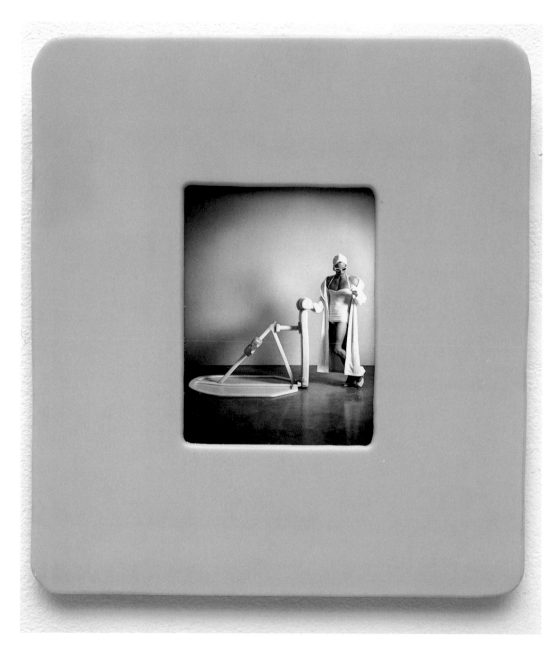

Matthew Barney. American, born 1967
Delay of Game (Manual) B. 1991
Black-and-white photograph in
prosthetic plastic frame, 14⁵/₈ ×
13 × ¹/₄" (37.2 × 33 × .6 cm)
The Museum of Modern Art, New
York. Acquired from Werner and Elaine
Dannheisser

Matthew Barney. American, born 1967
Pace Car for the Hubris Pill. 1991
Internally lubricated plastic, Teflon
fabric, cast glucose capsule, and cast
sucrose wedge, 53¹/₄" × 6'4¹/₂" × 48"
(135.2 × 194.3 × 121.9 cm)
The Museum of Modern Art, New
York. Acquired from Werner and Elaine
Dannheisser

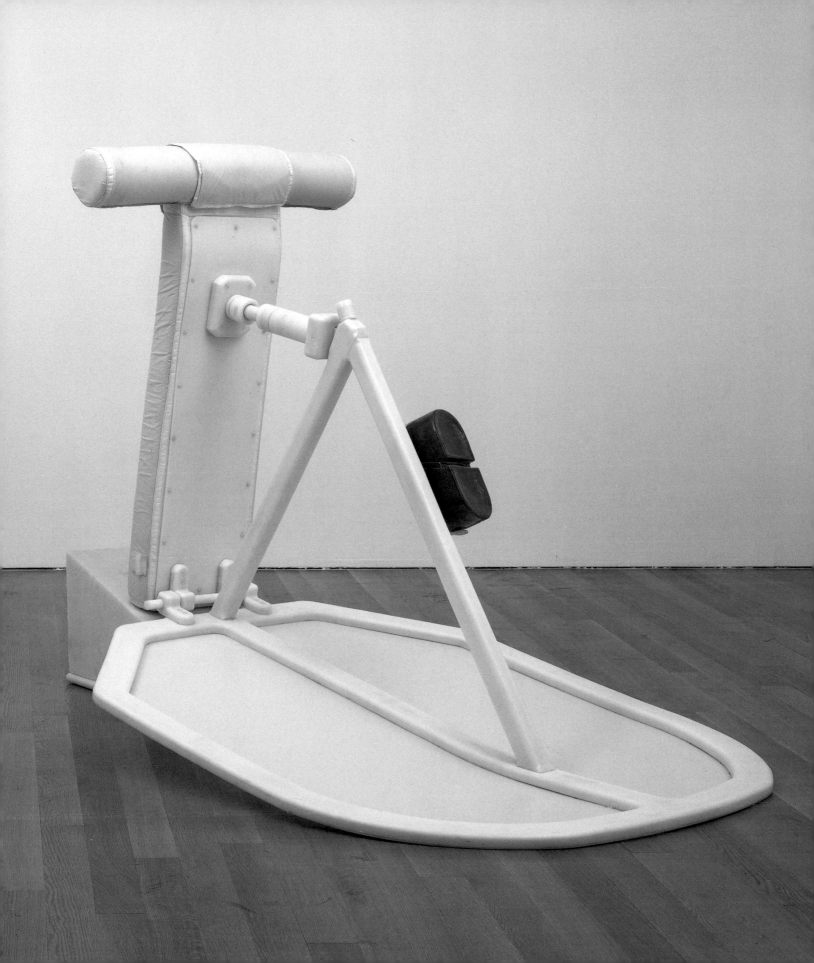

3 Trans-Histories

Nadine Robinson. British, born 1968
Tower Hollers (detail). 2002
Records, record players, speakers, speaker wires, acrylic on canvas, and wood, 13' × 37'8" × 36" (396 × 1148 × 91 cm)
Special commission by The Museum of Modern Art, New York; sound designer: Steve Shirk for Pink Noise Sound Environments, New York; technical consultant and installation: Kenneth Heitmuller, KH Studio, New York; produced (in part) at Harvestworks Digital Media Center, Artist-in-Residence Program
Courtesy the artist, New York

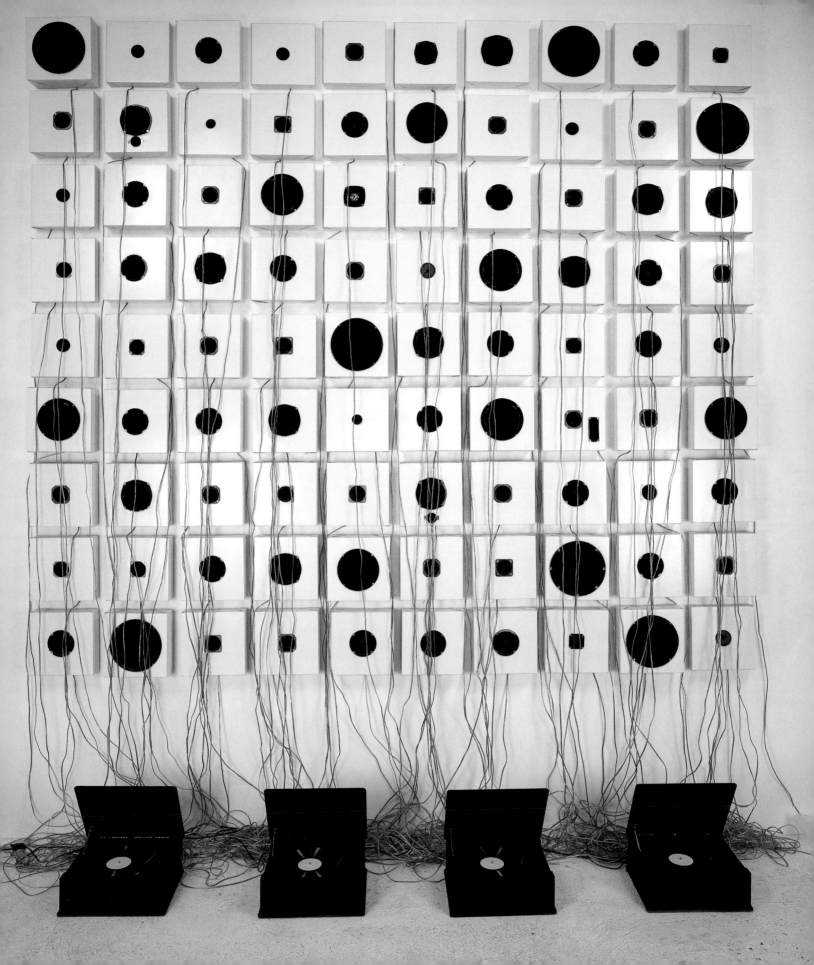

Marc Latamie. French, born
Martinique, 1952
Casabagass. 2002
Installation with wood shack,
sugarcane-juice machine, and
video, dimensions variable
Commissioned by The Museum
of Modern Art, New York; courtesy
the artist

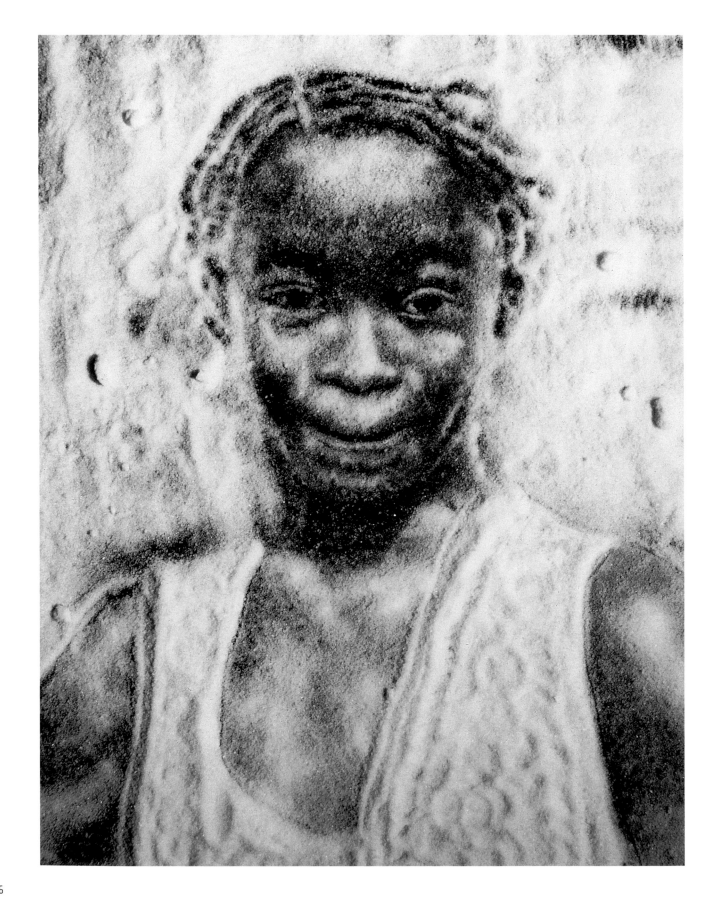

Vik Muniz. Brazilian, born 1961
Valentine, the Fastest. 1996
Gelatin silver print, 13³/₈ × 10⁷/₁₆"
(34 × 26.5 cm)
The Museum of Modern Art, New
York. Gift of Tricia Collins

Iñigo Manglano-Ovalle. American, born
Spain, 1961
Nocturne (tulipa obscura). 2002
Night-vision-enhanced real-time video
projection of native Afghan tulip with
live audio, dimensions variable
Commissioned by The Museum of
Modern Art, New York; courtesy
the artist and Max Protetch Gallery,
New York

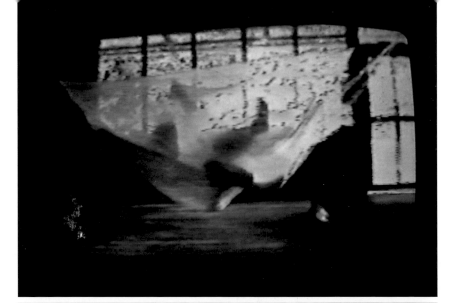

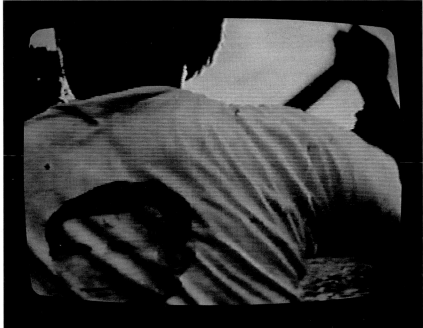

José Alejandro Restrepo. Colombian,
born France, 1959
Amazon Triptych (Tríptico Amazonas). 1994
Three-video installation, dimensions
variable
Courtesy the artist, Bogota

Fernando Alvim. Angolan, born 1963
Blending Emotions. 1997–99
Video, 26 min.
Produced by Sussuta Boé, contempo-
rary art producer; co-produced by
Angolan TV, European Commission;
and supported by Hans Bogatzke, Rui
Costa Reis, Angola
Courtesy the artist, Brussels

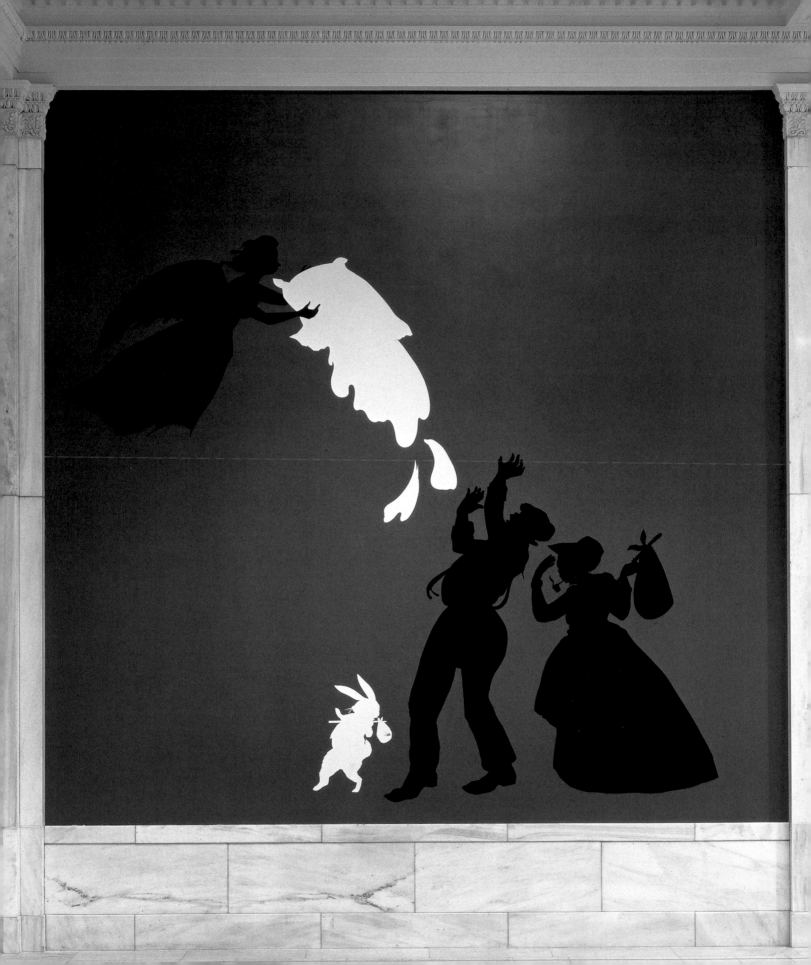

RAN AWAY, Glenn, a black male, 5'8", very short hair cut, nearly completely shaved, stocky build, 155-165 lbs., medium complexion (not "light skinned," not "dark skinned," slightly orange). Wearing faded blue jeans, short sleeve button-down 50's style shirt, nice glasses (small, oval shaped), no socks. Very articulate, seemingly well-educated, does not look at you straight in the eye when talking to you. He's socially very adept, yet, paradoxically, he's somewhat of a loner.

RAN AWAY, Glenn. Medium height, 5'8", male. Closely-cut hair, almost shaved. Mild looking, with oval shaped, black-rimmed glasses that are somewhat conservative. Thinly-striped black-and-white short-sleeved T-shirt, blue jeans. Silver watch and African-looking bracelet on arm. His face is somewhat wider on bottom near the jaw. Full-lipped. He's black. Very warm and sincere, mild-mannered and laughs often.

17/45 Glenn Ligon '93

17/45 Glenn Ligon '93

Kara Walker. American, born 1969
The Emancipation Approximation (detail). 1999
Cut paper on wall, dimensions variable; installation view at Carnegie International, Pittsburgh, 2000
Courtesy the artist and Brent Sikkema, New York

Glenn Ligon. American, born 1960
Untitled prints, from the portfolio *Runaways*. 1993
Two of ten lithographs, each, 15 15/16 × 11 15/16" (40 × 30.4 cm)
Publisher: Max Protetch Gallery, New York. Printer: Burnett Editions, New York. The Museum of Modern Art, New York. The Ralph E. Shikes Fund

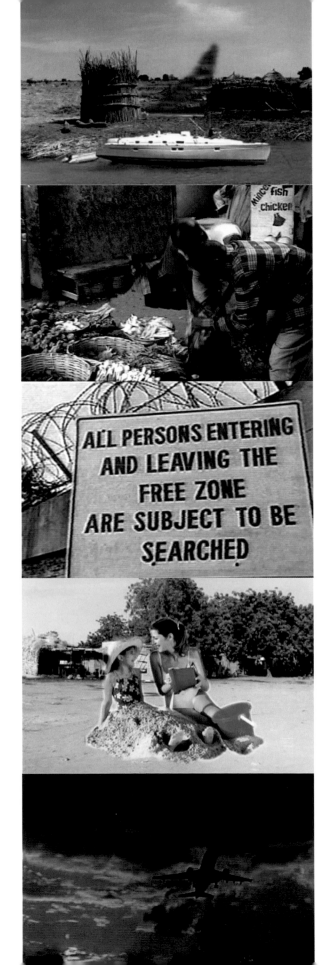

Fatimah Tuggar. Nigerian, born 1967
Meditation on Vacation. 2002
DVD projection/video collage,
4 min., 38 sec.
Special commission by The Museum
of Modern Art, New York; produced by
Binta Zarah Studios, New York, and
Art + Public, Geneva, Switzerland

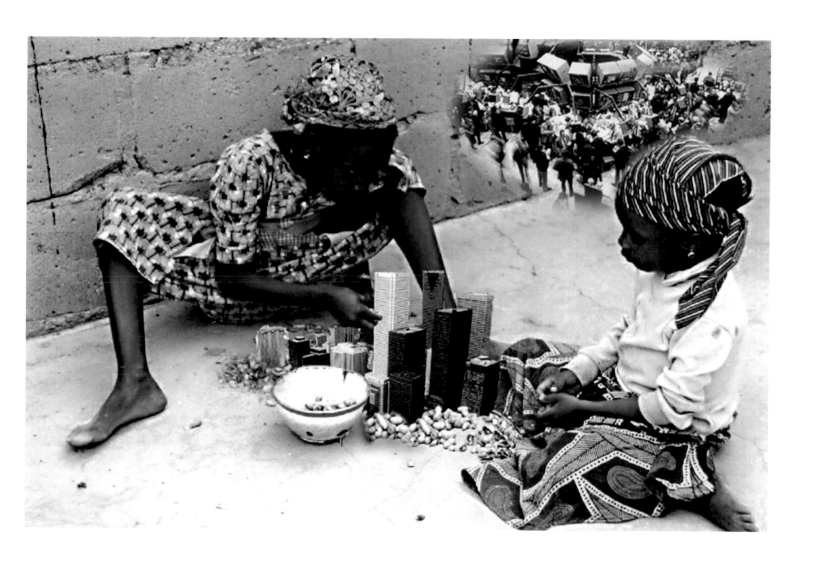

Fatimah Tuggar. Nigerian, born 1967
Sibling Rivalry. 1995
Ink-jet print mounted on Vinyl
with UV lamination, 20 × 30"
(50.8 × 76.2 cm)
Courtesy Binta Zarah Studios,
New York

4 Liquid Time

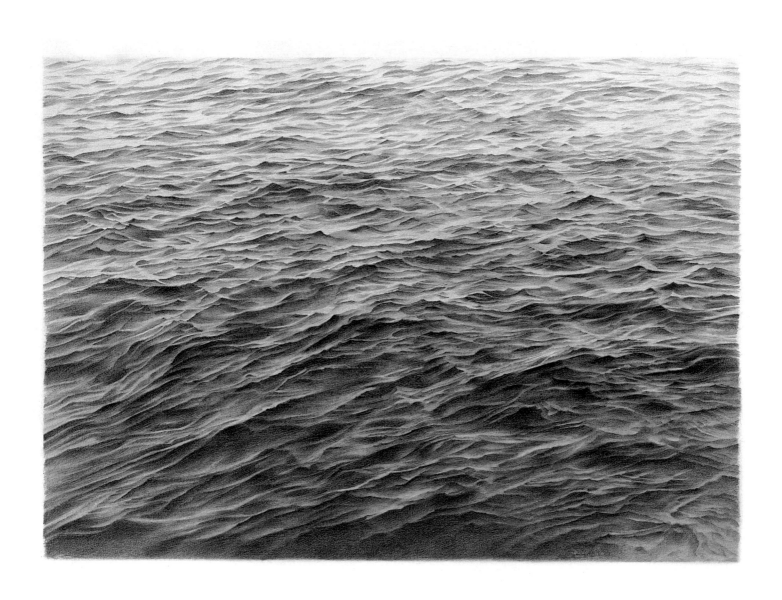

Vija Celmins. American, born Latvia,
1939
Untitled *(Ocean)*. 1970
Graphite on paper, 14 1/8 × 18 7/8"
(36 × 48 cm)
The Museum of Modern Art, New
York. Mrs. Florene M. Schoenborn
Fund

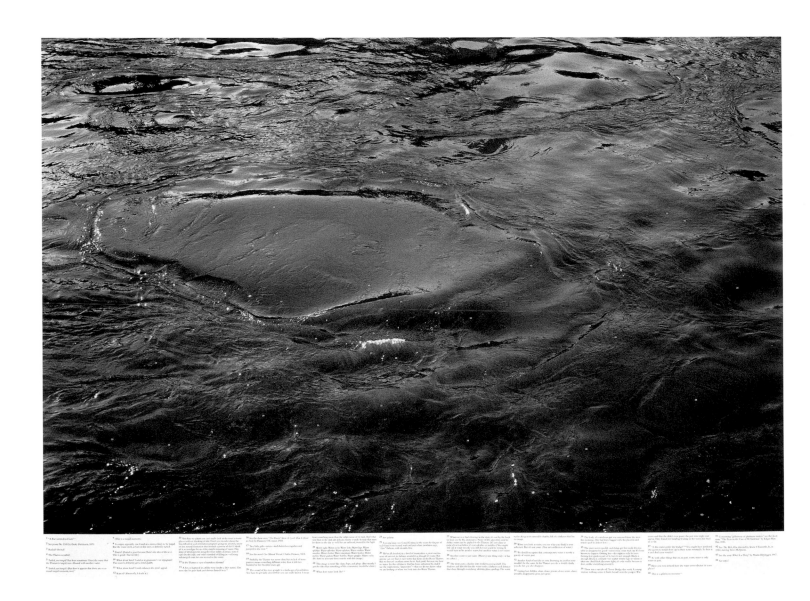

Roni Horn. American, born 1955
Still Water (The River Thames, for Example)—*Image B* and *Image L.* 1999
Two offset lithographs (photograph and text combined) on uncoated paper,
each 30 1/2 × 41 1/2" (77.5 × 105.4 cm)
Courtesy the artist and Matthew Marks Gallery, New York

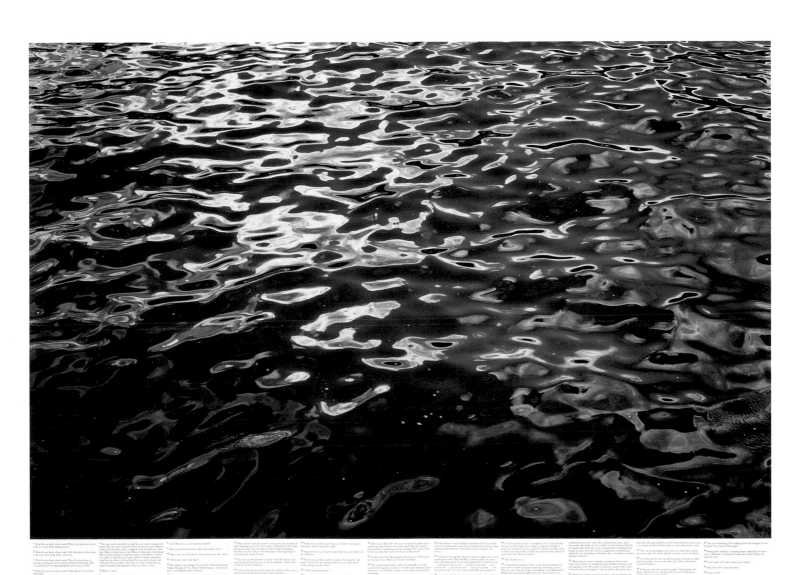

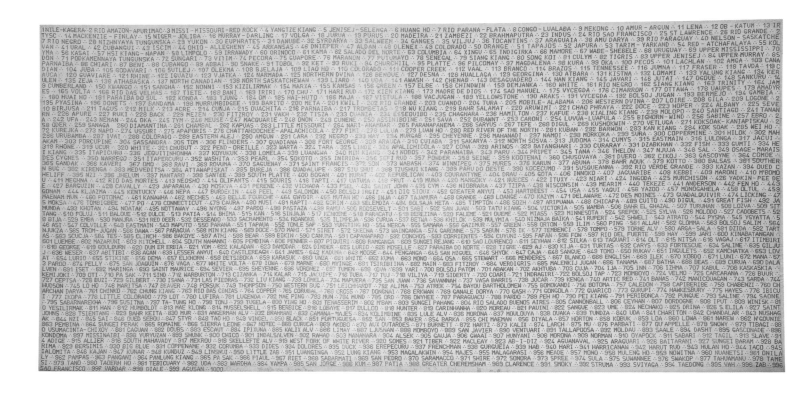

Alighiero e Boetti. Italian, 1940–1994
*Tapestry of the Thousand Longest Rivers of
the World (Arazzo dei mille fiumi più
lunghi del mondo).* 1971–79
Synthetic fiber embroidered on cotton
and linen, 8'3" × 17'7" (251.5 × 535.9 cm)
The Museum of Modern Art, New York.
Gift of Ronald S. Lauder, Jeanne C.
Thayer Fund, The Bernhill Fund, Patricia
Phelps de Cisneros Fund, gift of Agnes
Gund, and Barbara Jakobson Fund

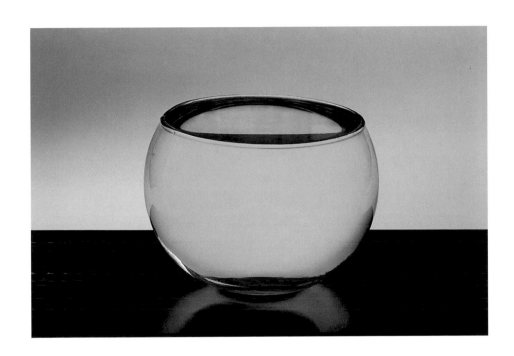

Waltercio Caldas. Brazilian, born 1946
Fulfilled Aquarium. 1981
Glass bowl and water, 9¹³/₁₆"
(25 cm) diam.
Collection Everardo Miranda,
Rio de Janeiro

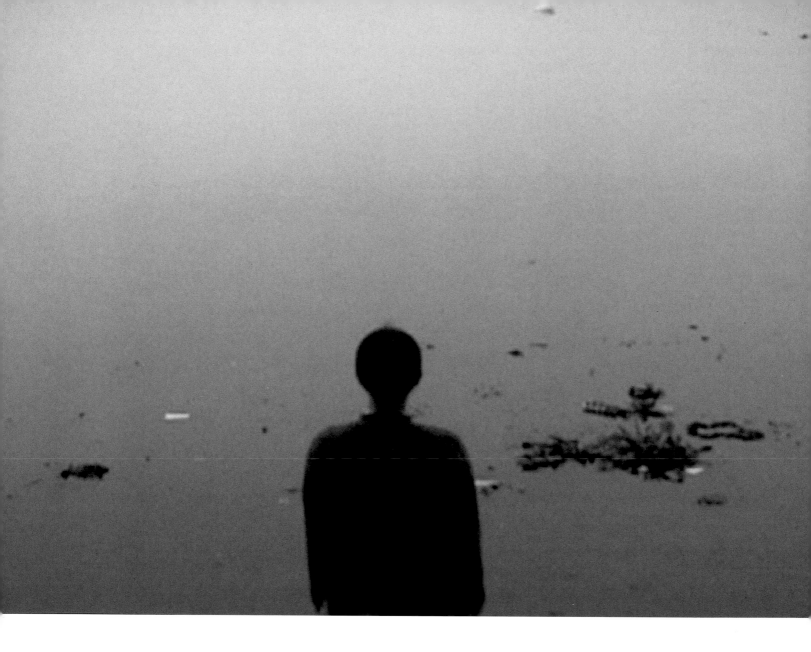

Kim Sooja. Korean, born 1957
A Laundry Woman. 2000
Single-channel video projection
Courtesy the artist and The Project,
New York, Los Angeles

Felix Gonzalez-Torres. American, born
Cuba. 1957–1996
Untitled. 1991
Offset lithographs on paper, endless
copies; each sheet 38 1/2 × 45 1/4" (17.8 ×
115 × 97.8 cm)
Collection Walker Art Center,
Minneapolis. T. B. Walker Acquisition
Fund, 1991

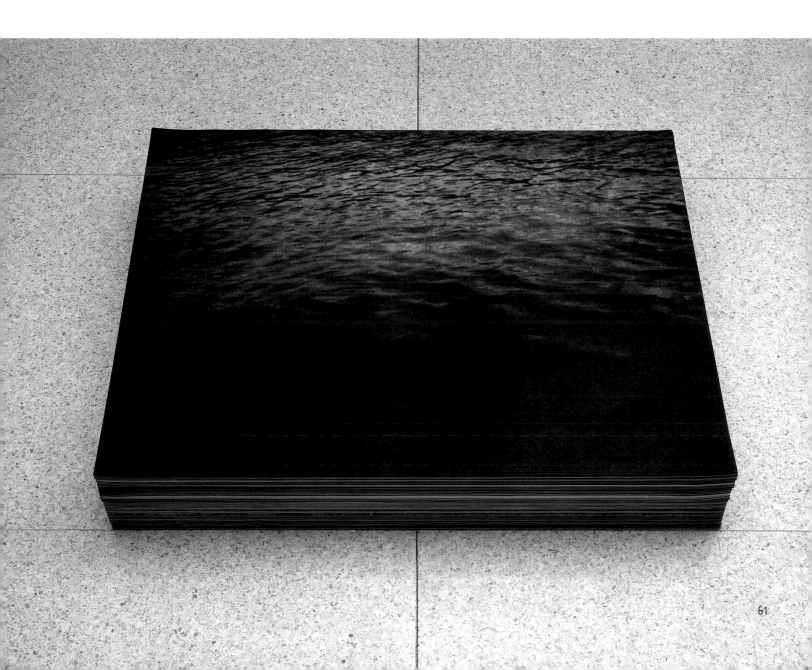

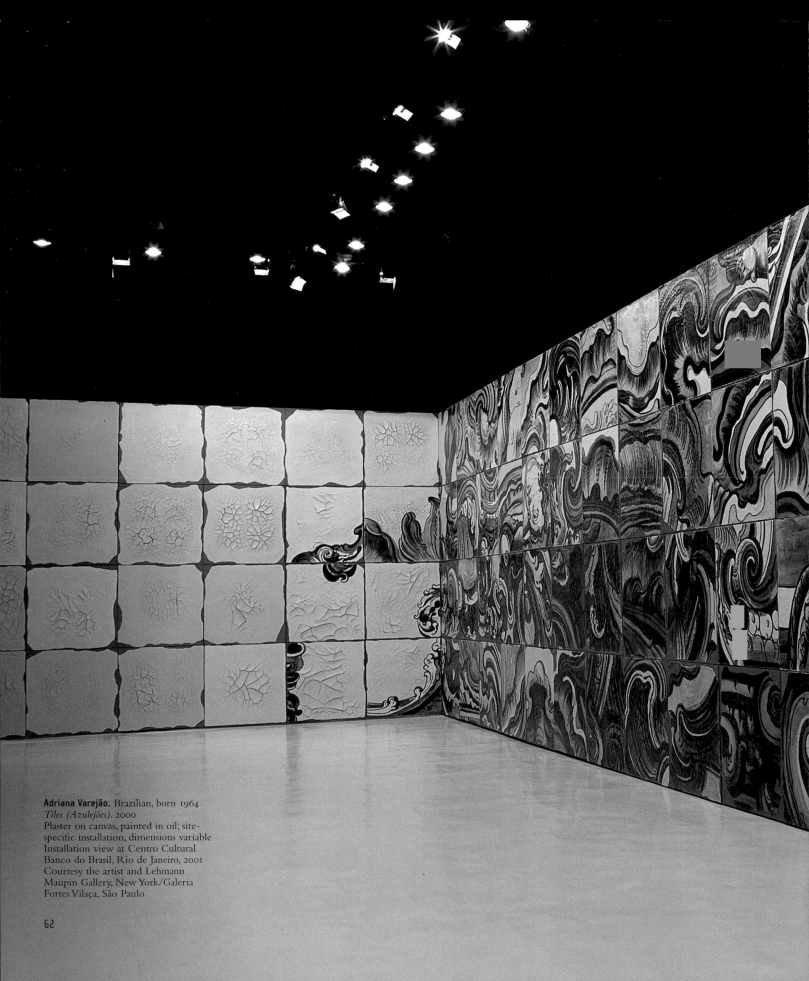

Adriana Varejão. Brazilian, born 1964
Tiles (Azulejões). 2000
Plaster on canvas, painted in oil; site-
specific installation, dimensions variable
Installation view at Centro Cultural
Banco do Brasil, Rio de Janeiro, 2001
Courtesy the artist and Lehmann
Maupin Gallery, New York/Galeria
Fortes Vilaça, São Paulo

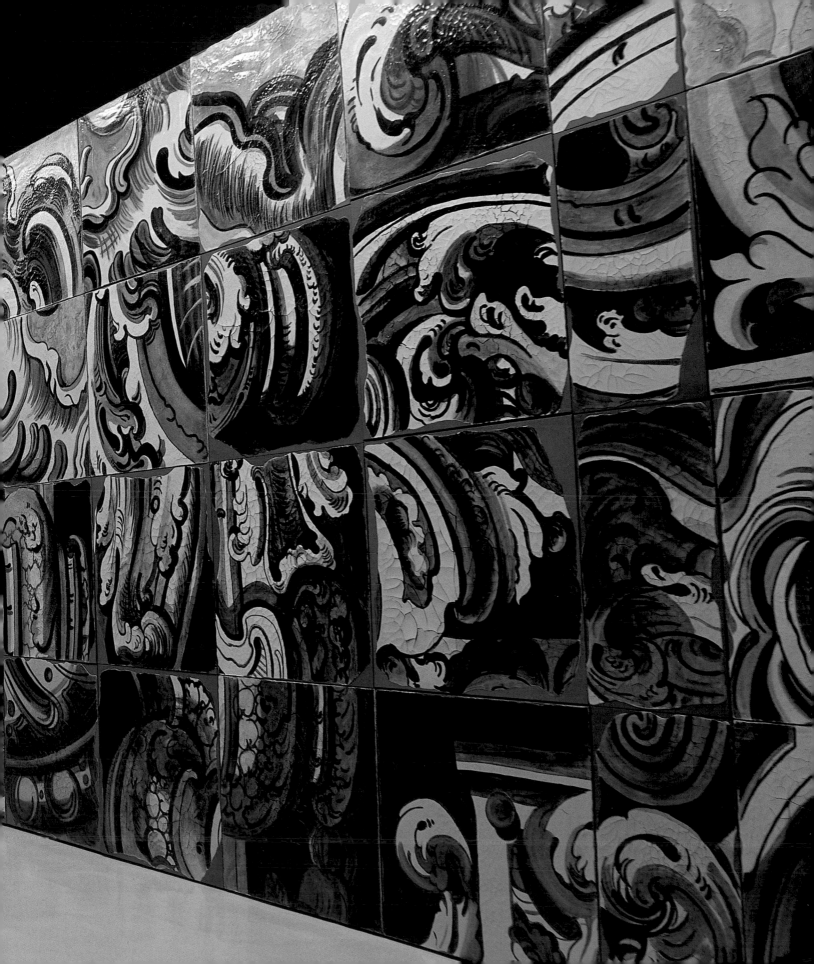

5 Mobility/ Immobility

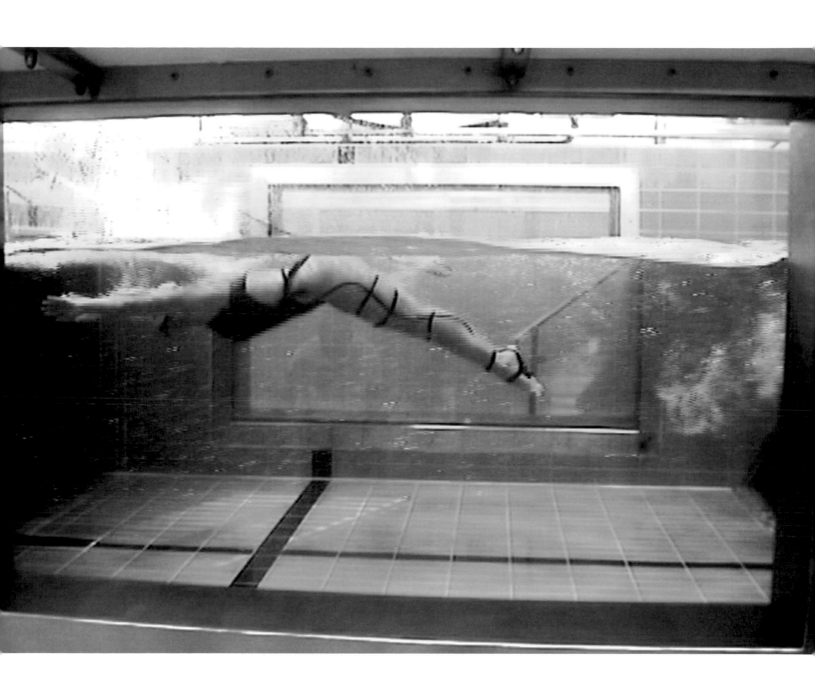

Angelika Middendorf, German,
born 1964
Outer Space. 1999
DVD video, 1 min., 20 sec. loop
Courtesy the artist, Berlin

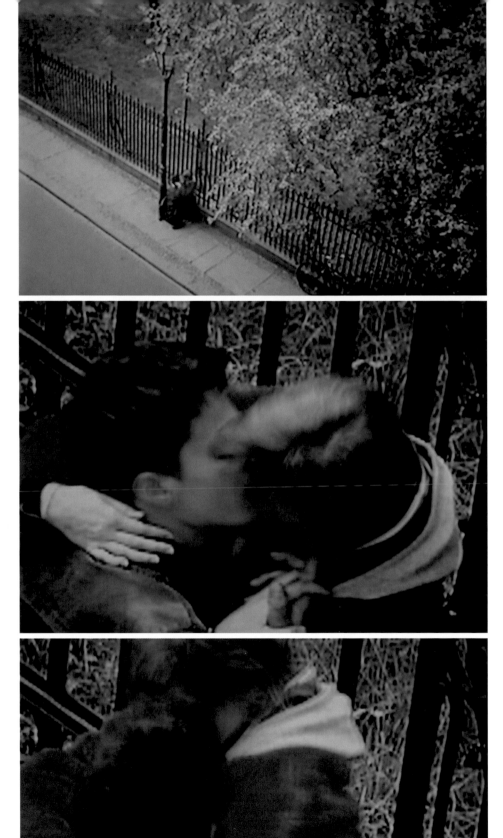

Douglas Gordon. Scottish, born 1966
Monument to X. 1998
Single-video projection
with radio sound
Courtesy the artist and Gagosian
Gallery, New York

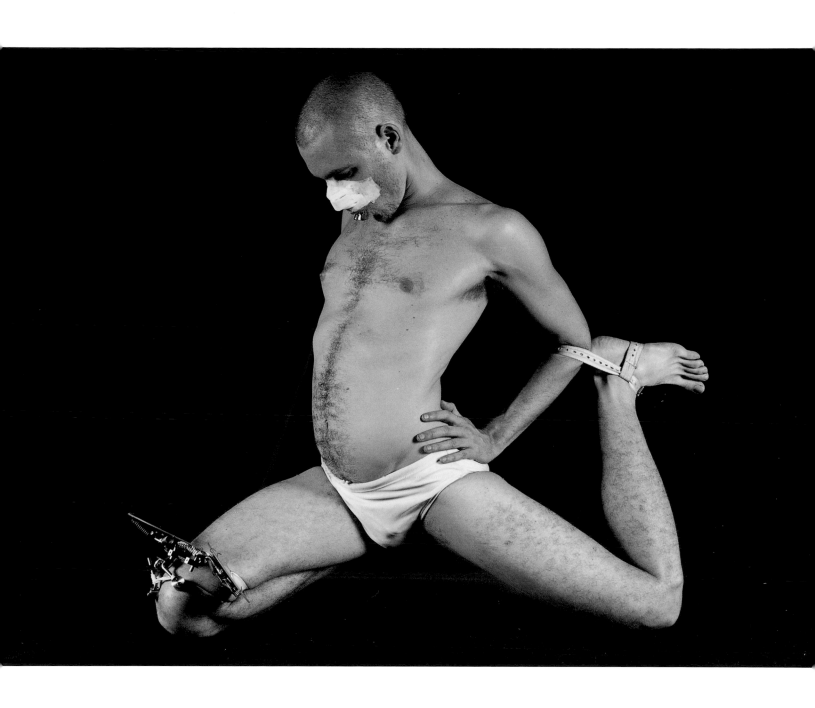

Michel Groisman. Brazilian, born 1972
Weaveair (Tear). 2000
Performance, 1 hr., 30 min.
Filmed by Pedro Lyra
Courtesy the artist, Galeria Baró Senna,
São Paulo, and Nina Maden, London

Zhu Jia. Chinese, born 1963
Forever. 1994
DVD video, 27 min. loop
Courtesy the artist, Beijing

Charles Ray. American, born 1953
Rotating Circle. 1988
Electric motor with disc, 9"
(22.9 cm) diam.
The Museum of Contemporary Art,
Los Angeles. Gift of the Lannan
Foundation

Paul Pfeiffer. American, born 1966
Goethe's Message to the New Negroes.
2001–02
CD-Rom, LCD screen, mounting arm,
and video, 3 min. loop
Courtesy the artist and The Project,
New York, Los Angeles

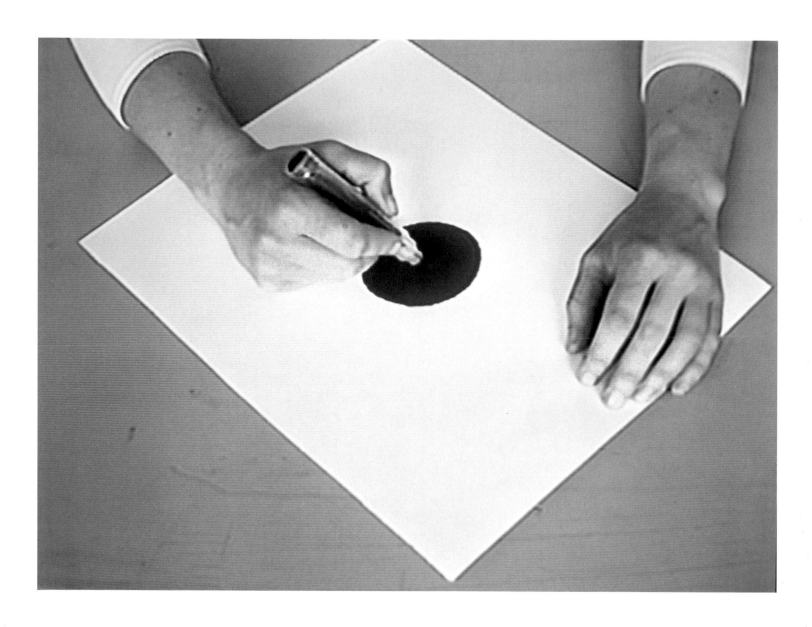

Ceal Floyer. British, born Pakistan, 1968
Ink on Paper. 1999
Video, 1 hr.
Courtesy the artist and Casey Kaplan, New York

Steven Pippin. British, born 1960
Fax 69. 1999
Office desk, two fax machines, and polycarbonated plexiglass, dimensions variable
Courtesy the artist and Gavin Brown's enterprise, Corp., New York

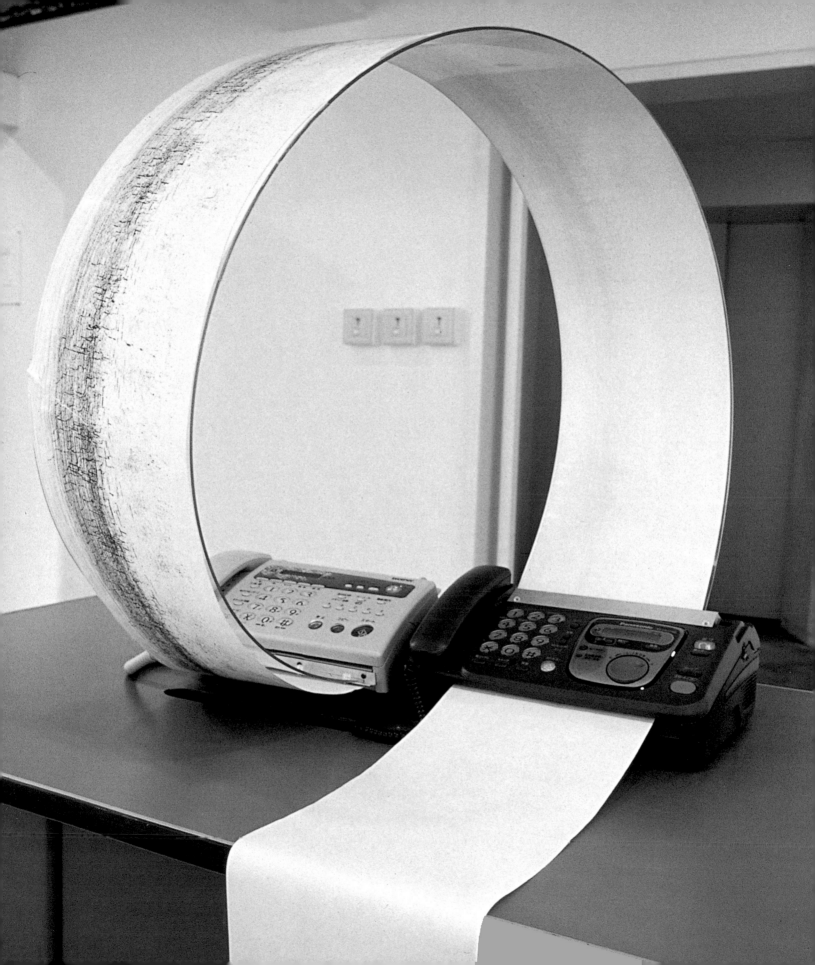

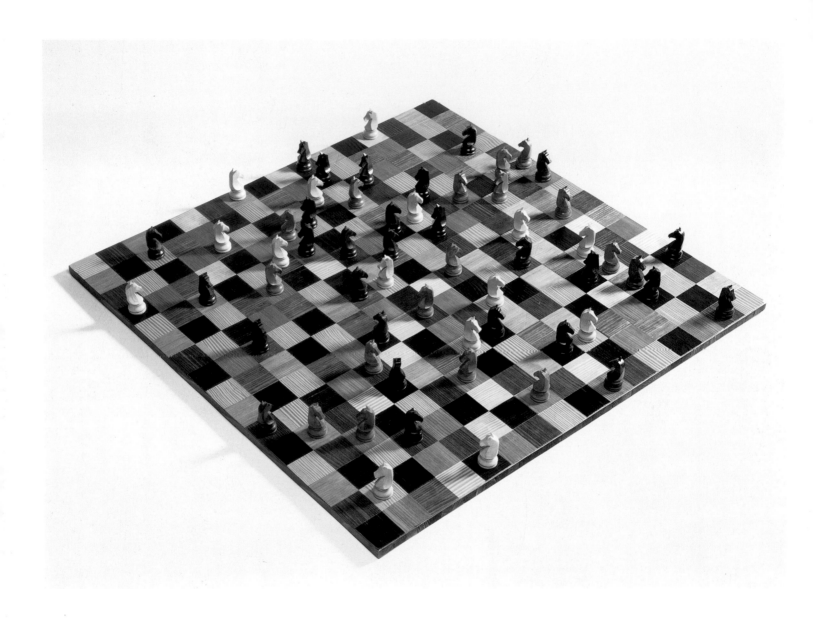

Gabriel Orozco. Mexican, born 1962
Horses Running Endlessly. 1995
Wood chess board and 128 knights,
3³/₈ × 34³/₈ × 34³/₈" (8.7 × 87.5 × 87.5 cm)
The Museum of Modern Art, New
York. Gift of Agnes Gund and Lewis B.
Cullman in honor of Chess in the
Schools

Tatsuo Miyajima. Japanese, born 1957
Counter Spiral. 1998
LED, IC, and electrical wire, 12'¹/₈" ×
23⁵/₈" × 23⁵/₈" (300 × 60 × 60 cm)
Courtesy the artist and Luhring
Augustine, New York

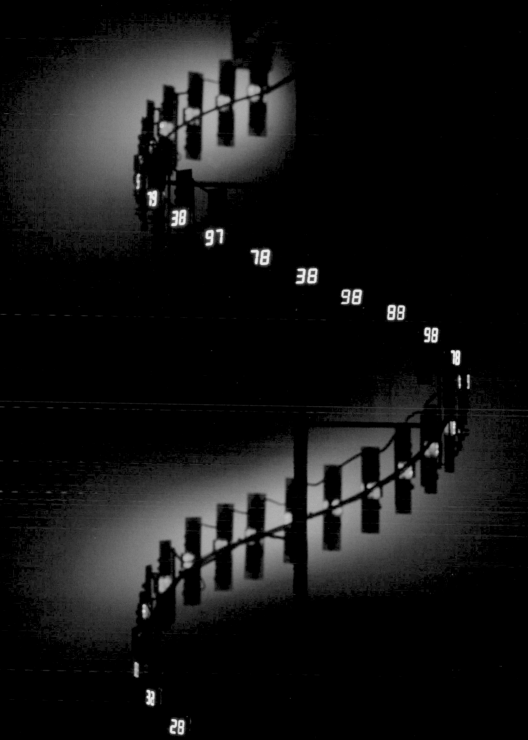

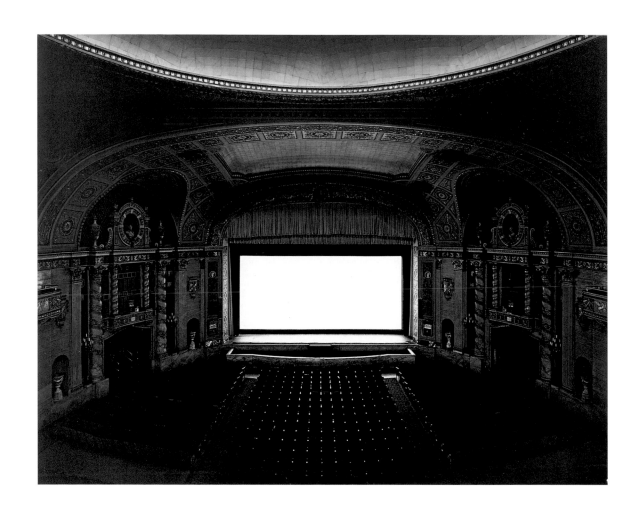

Hiroshi Sugimoto. Japanese, born 1948
Hall No. 7. 1978
Gelatin silver print, 16 9/16 × 21 3/8"
(42.1 × 54.4 cm)
The Museum of Modern Art, New
York. David H. McAlpin Fund

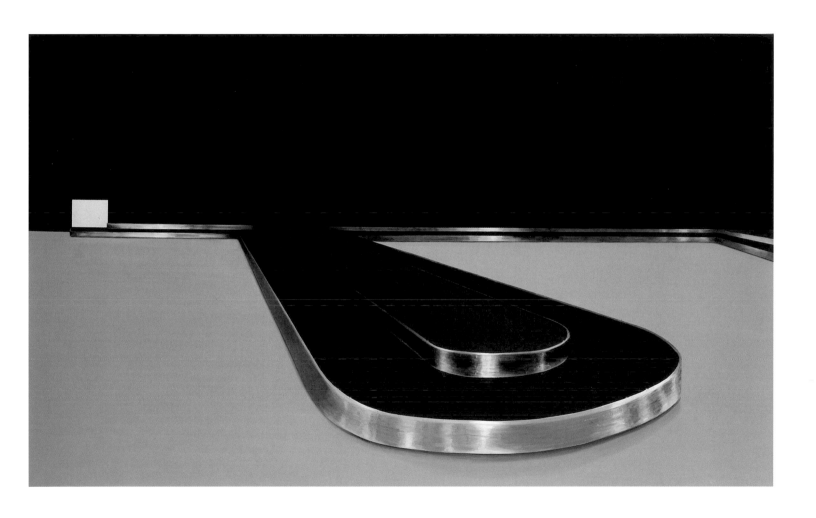

Guillermo Kuitca. Argentinean, born 1961
Terminal. 2000
Oil on canvas, 77 × 125 ¹/₂"
(195.6 × 318.8 cm)
Courtesy the artist and Sperone
Westwater Gallery, New York

Acknowledgments

The preparation of this exhibition and publication could not have been realized without the dedicated efforts and generous assistance of the individuals and organizations listed below.

We thank the following lenders to the exhibition for making *Tempo* possible: Fernando Alvim, Brussels; Agata Boetti, Paris; Louise Bourgeois, New York; The Brant Foundation, Greenwich, Conn.; Ricardo Brito Santos Pereira, São Paulo; Ceal Floyer, London; Ana Maria and José Celso Gontijo, Brasília; Michel Groisman, Rio de Janeiro; Gropello Collection; Rebecca Horn, Bad König-Zell; Roni Horn, New York; A.C. Hudgins, Englewood, N.J.; Norma Jeane, Milan; Zhu Jia, Beijing; Kim Sooja, New York; Marc Latamie, New York; Iñigo Manglano-Ovalle, Chicago; Matthew V. McCaslin, New York; Cildo Meireles, Rio de Janeiro; Angelika Middendorf, Berlin; Burton S. Minkoff, Miami; Everardo Miranda, Rio de Janeiro; Steven Pippin, London; Lea Prado, São Paulo; Peter Regli, Zurich; José Alejandro Restrepo, Bogotá; Frances Reynolds Marinho, Rio de Janeiro; Pipilotti Rist, Zurich; Craig Robins; Nadine Robinson, Brooklyn; Alfredo and Rose Setubal, São Paulo; Fatimah Tuggar, Brooklyn; Adriana Varejão, Rio de Janeiro; Kara Walker, New York; Roger Wright-Bassini/Playfair Associate, São Paulo; Erwin Wurm, Vienna; Private collections. Caixa Geral de Depósitos, Lisbon; The Museum of Contemporary Art, Los Angeles; The Walker Art Center, Minneapolis; Caisse des depôts et consignations—Mission Mécénat, Paris; The Museum of Modern Art, New York; Banco Itaú, S.A., São Paulo; Instituto Takano, São Paulo.

A special debt of gratitude is owed the many members of the Museum's staff for their important contributions to this endeavor: Nancy Adelson, Assistant General Counsel; Daria Azim, Curatorial Assistant, Photography; Ramona Bannayan, Director of Collections Management and Exhibition Registration; Mary Lea Bandy, Deputy Director for Curatorial Affairs, and Chief Curator, Film and Media; Maria D. Beardsley, Coordinator of Exhibitions; Harriet Schoenholz Bee, Editorial Director, Publications; Laura Beiles, Public and Family Programs Assistant, Education; Josiana Bianchi, Public Programs Coordinator, Education; Sydney Briggs, Senior Assistant Registrar; Holly Boerner, Assistant to the Director, Imaging Services; Allegra Burnette, Creative Manager, Digital Media; Mikki Carpenter, Director, Imaging Services; Stephen Clark, Associate General Counsel; Carol Coffin, Executive Director, The International Council; Claire Corey, Production Manager, Graphics; James Coddington, Chief Conservator; Lianor de Cunha, Administrative Assistant, Painting and Sculpture; Kathy Curry, Assistant Curator for Research and Collections, Drawings; Monika Dillon, Director, Exhibition Funding, Associate Director, External Affairs; Edmund D'Inzilio, Projectionist, Media Services; Janis Ekdahl, Librarian, Collection Development; John Elderfield, Chief Curator at Large; Carrie Eliott, Administrative Assistant, Painting and Sculpture; Jessica Ferraro, Communications; Peter Foley, Director, Marketing; Peter Galassi, Chief Curator, Photography; Gary Garrels, Chief Curator, Drawings, and Curator, Painting and Sculpture; Elliott Grant, Assistant to the Director, Exhibition Design and Production; Jennifer Grausman, Manager, Exhibition Funding; Tom Griesel, Fine Arts Photographer; Roger Griffith, Associate Conservator; Mary Hannah, Development Officer; Joe Hannan, Editor, Writing Services; Cassandra Heliczer, Associate Editor, Publications; Mattias Herold, Manager, Painting and Sculpture; Amy Horschak, Museum Educator, Coordinator of Internships and International Adult Education Programs; Milan Hughston, Chief of Library and Museum Archives; Robert Jung, Assistant Manager, Art Handling and Preparation; Charles Kalinowski, Technical Director, Media Services; Kate Keller, former Head, Fine Arts Imaging; Beatrice Kernan, Assistant Director for Exhibitions and Collection Support; Susan Kismaric, Curator, Photography; Zdenek Kriz, Projectionist, Media Services; Katherine Krupp, Paper Products Manager, Retail Administration; Erik Landsberg, Manager, Image Technology; Norman Laurila, Book Manager, Retail Administration; Jay Levenson, Director, International Program; Cary Levine, Administrative Assistant, Painting and Sculpture; Ellen Lindner, Associate Producer, Digital Media; Maria Lopez, Intern, Sculpture Conservation; Glenn D. Lowry, Director of the Museum; Michael Maegraith, Publisher; Burns Magruder, Senior Graphic Designer; Catharina Manchada, Curatorial Assistant, Painting and Sculpture; Michael Margitich, Deputy Director, External Affairs; Elizabeth Margulies, Family Programs Coordinator, Education; Rachel Mayer, Coordinator, Architecture and Design; Kynaston McShine, Acting Chief Curator, Painting and Sculpture; Kim Mitchell, Director, Communications; Melanie Monios, Assistant Director, Visitor Services; Jerome Neuner, Director, Exhibition Design and Production; Patrick O'Flynn, Administrative Services; Peter Omlor, Manager of Art Preparation and Handling; Susan Palamara, Associate Registrar; Jane Panetta, Legal Assistant, General Counsel; Avril Peck, Loan Assistant, Painting and Sculpture; Peter Perez, Foreman, Frameshop, Exhibition Design and Production; Francesca Pietropaolo, Curatorial Assistant, Drawings; Diana Pulling, Executive Assistant to the Director; Edward Pusz III, Director, Graphic

Design; Marci Regan, Assistant to the Coordinator, Exhibitions; Eva Respini, Curatorial Assistant, Photography; Elizabeth Riggle, Preparator; Terence Riley, Chief Curator, Architecture and Design; Jennifer Roberts, Study Center Supervisor, Prints and Illustrated Books; Maile Rodríguez, Publicity Coordinator, Communications; Francesca Rosenberg, Acting Director, Education; Cora Rosevear, Associate Curator, Painting and Sculpture; Gina Rossi, Senior Book Designer, Publications; Jennifer Russell, Deputy Director for Exhibitions and Collection Support; Martina Salisbury, Senior Designer, Graphic Design; Laura Santaniello, Manager, Photography; Marc Sapir, Director of Production, Publications; Mari Shinagawa-Thanner, Production Manager, Exhibition Design and Production; Diana Simpson, Director, Visitor Services; Gregory Singer, Projectionist, Media Services; Suzanne Stern, Assistant to Deputy Director of Education; Robert Storr, Senior Curator, Painting and Sculpture; Mark Swartz, Writer/Editor, Marketing; Anthony Tavolacci, Projectionist, Media Services; Jenny Tobias, Associate Librarian, Reference; Lilian Tone, Assistant Curator, Painting and Sculpture; Anne Umland, Associate Curator, Painting and Sculpture; Trine Vanderwall, Senior Assistant Registrar; Kirk Varnedoe, Chief Curator, Painting and Sculpture; Richard Vikse, Project Manager, New Building; Steven West, Art Move Coordinator, Registrar; Deborah Wye, Chief Curator, Prints and Illustrated Books; Patricia Whitman, Contemporary Arts Council; Marc Williams, Preparator; Carlos Yepes, Assistant Coordinator of Exhibitions; Christopher Zichello, Production Manager, Publications.

We are also most grateful to the following: Carolyn Bane, Press Office, P.S. 1 Contemporary Art Center; Anna Baldacci, Milan; Jean Bickley, The Brant Foundation, Greenwich, Conn.; Ana Buarque de Hollanda, Adriana Varejão Studio, Rio de Janeiro; Iris Bucholz, Sussuta Boé Contemporary Art Producer, Brussels; Galerie Evelyne Canus, Paris and Basel; Jean-François Chougnet, Directeur Général, Cité des Sciences et de l'Industrie de la Villette, Paris; Francesca Dal Lago, Montreal; Corinna Durland, Gavin Brown's enterprise, Corp., New York; Hank Dwyer, Ann Gale, Katherine Halbreich, Heather Scanlon, Walker Art Center, Minneapolis; Virginia Edwards, Alma Ruíz, Jeremy Strick, Museum of Contemporary Art, Los Angeles; Feigen Contemporary Gallery, New York; Margarida Ferraz Antonio Pinto Ribeiro, Caixa Geral de Depósitos, Lisbon; Sandra Frank, Atelier Erwin Wurm, Vienna; Elizabeth Franzen, Julián Zugazagoitia, Solomon R. Guggenheim Museum, New York; Jeannie Freilich-Sondik, Marian Goodman Gallery, New York; Claudia Friedli, Marc Payot, Galerie Hauser & Wirth, Zurich; Giovanni García, Jenni Liu, The Project, New York, Los Angeles; Sandra Gering Gallery, New York; Kate Gilmartin, Marlborough Gallery, New York; Arnold Glimcher, Jeffrey Burch, Pace Wildenstein, New York; Jerry Gorovoy, Wendy Williams, Louise Bourgeois Studio, New York; Amy Gotzler, Sean Kelly Gallery, New York; José and Florette Hayot, Martinique; Thomas Heyden, Conservator, Neues Museum, Staatliches Museum für Kunst und Design, Nürnberg; Hans Werner Holzwarth, Peter Weyrich, Rebecca Horn Studio, Bad König-Zell; Milena Kalinovska, Washington, D.C.; Jeff Keese, Galeria Fortes Vilaça São Paulo; Milan Knizak, General Director, Narodni Galerie, Prague; Gilles Lacombe, Paris; Meghan LeBorious, Janine Antoni Studio, New York; Roland Augustine, Lawrence Luhring, Natalia Mager, Claudia Altman-Siegel, Luhring Augustine, New York; Valter Manhoso, Caixa Geral de Depósitos, Lisbon; Matthew Marks Gallery, New York; Claudine Martin, Galerie de France; Melissa Martin, Janine Antoni Studio, New York; Gudrun Meyer, Thomas Schulte Gallery, Berlin; Luis Pérez Oramas, Caracas; Alkistis Poulopoulou, Galerie Art: Concept, Paris; Muriel Quancard, Casey Kaplan Gallery, New York; José Ignacio Roca, Bogotá; Deborah Roldán, The Metropolitan Museum of Art, New York; Andrea Rosen, John Connelly, Michelle Reyes, Andrea Rosen Gallery, New York; Lisa Ross, Roni Horn Studio, New York; Jiri Sevcik, Prague; Brent Sikkema, Michael Richards, Brent Sikkema Gallery; John Tain, Paris; Tang Di, Beijing; Jessie Washburne-Harris, Gagosian Gallery, New York; Shoshana Wayne Gallery, Santa Monica, California; Emily Wei, New York; Marcos Weinstock, Instituto Takano, São Paulo; Angela Westwater, Sperone Westwater Gallery, New York.

—P.H., R.M., M.B.

Trustees of The Museum of Modern Art